£14.95.

Picasso on Paper

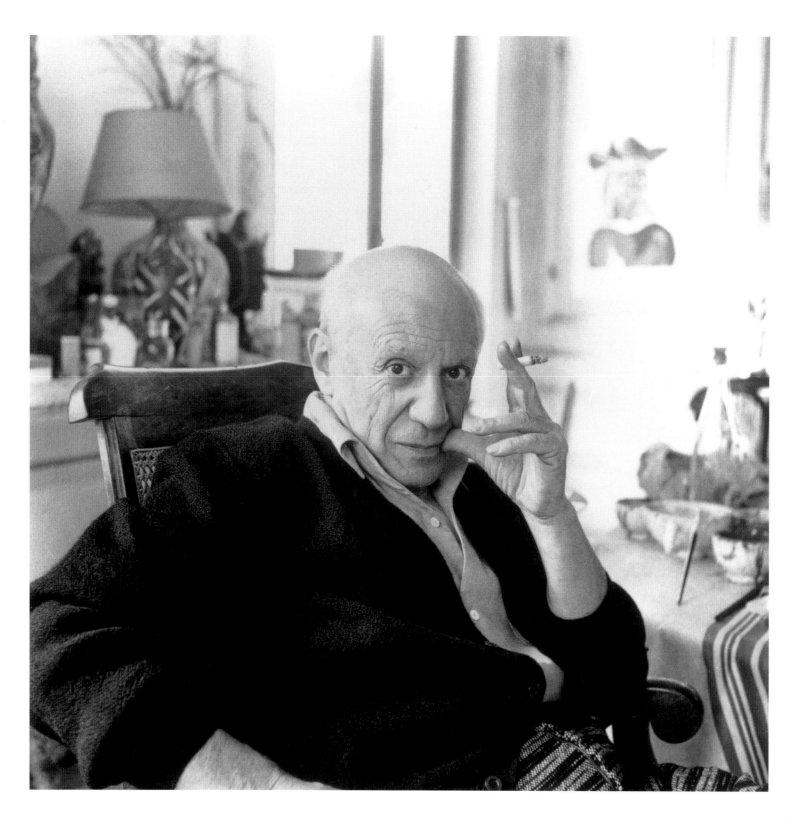

Patrick Elliott

Picasso on Paper

National Galleries of Scotland
Edinburgh 2007

Published by the Trustees of the National Galleries
of Scotland to accompany the exhibition *Picasso on Paper*
held at the Dean Gallery, Edinburgh from 14 July
until 23 September 2007

ISBN 978 1 903278 87 1

Organised in collaboration with the Graphische Sammlung
of the Staatsgalerie Stuttgart

Sponsored by

XXIII
RAVELSTON TERRACE

Supported by

A&B
Arts & Business
NEW PARTNERS

The proceeds from the sale of this book go
towards supporting the National Galleries of Scotland.

www.nationalgalleries.org

Designed and typeset in Aldus by Dalrymple
Printed in Belgium on Gardapat Kiara 150gsm
by Die Keure

Front cover: Pablo Picasso, *Portrait of Dora Maar*, 1941
Staatsgalerie Stuttgart, Graphische Sammlung (cat.43)

Frontispiece: *Picasso at 'La Californie', Cannes, 1958*
Photograph by Lee Miller
© Miller Archives, England 2007

Foreword and Acknowledgements 7

Sponsor's Foreword 9

Picasso, his Prints and his Printers 11

Catalogue 27

Selected Bibliography 143

Notes 144

Foreword and Acknowledgements

Picasso is widely regarded as the greatest artist of the twentieth century yet, surprisingly, there has never been a major Picasso exhibition in Scotland. Thanks to the Staatsgalerie Stuttgart, and specifically that Gallery's world-renowned graphics department (the Graphische Sammlung), we are able to correct this unhappy fact. This exhibition of some one hundred and twenty-five of Picasso's greatest prints and drawings shows the extraordinary range of his achievement over a period of seventy years, from a pastel drawing made when he was still a teenager, to a dextrous ink drawing made in 1971, when he was eighty-nine years old. For Picasso, printmaking was not simply a way of reproducing images he had already made in his paintings; instead it was a creative process in its own right, indeed he often developed ideas through the process of printmaking, and then introduced them into his paintings. As Patrick Elliott shows, Picasso often changed his technical approach for practical reasons. So, for example, in the mid-1940s he began making lithographs in a print workshop in the north of Paris in order to escape the friends and dealers who flocked to his studio in the centre of the city; then, when he moved to the south of France, he abandoned etching and lithography because he no longer had the necessary assistance and equipment, and instead took up the linocut technique because a linocut printer lived nearby. In a similar way, stylistic changes might be prompted by changes in his love life. This intimate relationship between Picasso's life and art is one reason for his enduring popularity, and it is particularly apparent in his graphic art.

The Graphische Sammlung of the Staatsgalerie Stuttgart boasts one of the world's greatest collections of Picasso's graphic work. The Gallery began collecting early on: two early Rose Period etchings (cats.2 and 4) were acquired in 1913, the year they were printed.
A lithograph was added to the collection in 1925. Unfortunately, the Gallery's record books were destroyed by bombing during the Second World War and we no longer know the details behind these early acquisitions. But the bulk of the collection was formed in the 1950s and 1960s; many of the works were purchased and others were given by Picasso's dealer, Daniel-Henry Kahnweiler. More recent acquisitions include Picasso's celebrated series of lithographs of a bull (cat.48), presented by the SuedWestLB, LBS and SV in 1993.

The Staatsgalerie has generously agreed to lend nearly one hundred of the very best works from its collection. This project was initially conceived and developed by Michael Clarke, Director of the National Gallery of Scotland, on the basis of a kind suggestion made by Professor Dr Christian von Holst, former Director of the Staatsgalerie. Mr Clarke and his colleagues at the National Galleries of Scotland wish to express their warmest thanks to Professor Dr Ulrike Gauss, recently retired Head of the Graphische Sammlung at the

Staatsgalerie, who has supported these plans with characteristic enthusiasm. The project has been carried through to completion by Patrick Elliott, Chief Curator at the Scottish National Gallery of Modern Art, working with colleagues from Stuttgart. We would particularly like to thank Sean Rainbird, the new Director of the Staatsgalerie Stuttgart; Dr Hans-Martin Kaulbach and Dr Corinna Höper, Curators of the Graphische Sammlung; Peter Frei, Registrar; Reinhard Mümmler, Registrar; Susanne Ruf, Regine Diercks-Staiger, Sylvie Katzmarczyk and Peter Tschachotin of the Department of Paper Conservation; and Gerlinde Röbel and Martina Zacher, Secretaries.

While the Stuttgart collection forms the basis of the exhibition, we have added a number of works from British public and private collections, including our own holdings, which are particularly rich in artists' books. Amongst the other lenders we would like to thank are Duncan Robinson, Director, The Fitzwilliam Museum, Cambridge and his colleagues David Scrase, Assistant Director (Collections) and Craig Hartley, Senior Assistant Keeper (Prints); Antony Penrose; Professor Henry and Sula Walton; Dr John Scally, Director of Collections, University of Edinburgh; Jacky McBeath, Collections Support Officer, University of Edinburgh; and the Deschler Family.

We are grateful to Dr Elliott for writing the catalogue. Elizabeth Cowling, Reader in the Department of the History of Art at the University of Edinburgh and a world-renowned Picasso scholar, read the text and made many corrections and helpful suggestions. Marilyn McCully gave valuable assistance in cataloguing the drawing of Marie-Thérèse Walter (cat.17). We also thank Aldo Crommelynck and Frederick Mulder for assistance with cataloguing. Illustrations for the catalogue essay were kindly provided by Ursula Frei and Gret Quinn of the Edward Quinn Archive; Lucien Clergue; David Douglas Duncan; Linda Briscoe Myers, Assistant Curator of Photography, Harry Ransom Center, the University of Texas at Austin; and Eric Mourlot. At the National Galleries of Scotland we thank Anne Galastro, who has worked as the Research Assistant on this project; Lauren Rigby and Daniel Herrmann, Curators; Ann Simpson, Senior Curator, Archives and Library; and Janis Adams, Head of Publishing and Christine Thompson, Publishing Manager, who have produced the catalogue. We would also like to thank Robert Dalrymple for his catalogue design. Lastly and importantly, we are immensely grateful to Sundial Properties' XXIII Ravelston Terrace development for sponsoring the exhibition, along with additional support from a Scottish Executive Arts and Business New Arts Sponsorship Award.

John Leighton *Director-General, National Galleries of Scotland*

Keith Hartley *Acting Director, Scottish National Gallery of Modern Art*

Sponsor's Foreword

XXIII Ravelston Terrace is delighted to be supporting this major exhibition of work by Pablo Picasso, perhaps the most influential artist of the twentieth century.

Picasso on Paper celebrates his unrivalled record of leading artistic movements and techniques for nearly eighty years through his extraordinary graphic art. The one hundred and twenty-five works in the exhibition, drawn principally from the Staatsgalerie in Stuttgart, chart his journey from the etchings of his Rose Period in the early years of the twentieth century, to the pre-war cubist images and the surrealist works of the 1920s and 1930s to the vibrant linocuts of the 1950s, and the sexually charged works of his later years.

Picasso constantly challenged aesthetic and technical conventions, challenges that were rapidly absorbed and accepted within the mainstream of the artistic establishment. Our regeneration of XXIII Ravelston Terrace, through the vision of Allan Murray Architects has produced a curving, glass-clad structure quite unlike any other apartment development in Edinburgh. We believe that, in its own way, it too will become a classic of its time.

With this in mind, Sundial, together with the National Galleries of Scotland, hope that you enjoy this spectacular exhibition of Europe's greatest modern artist in one of Europe's finest cities.

William Gray Muir *Director, Sundial Properties, Edinburgh*

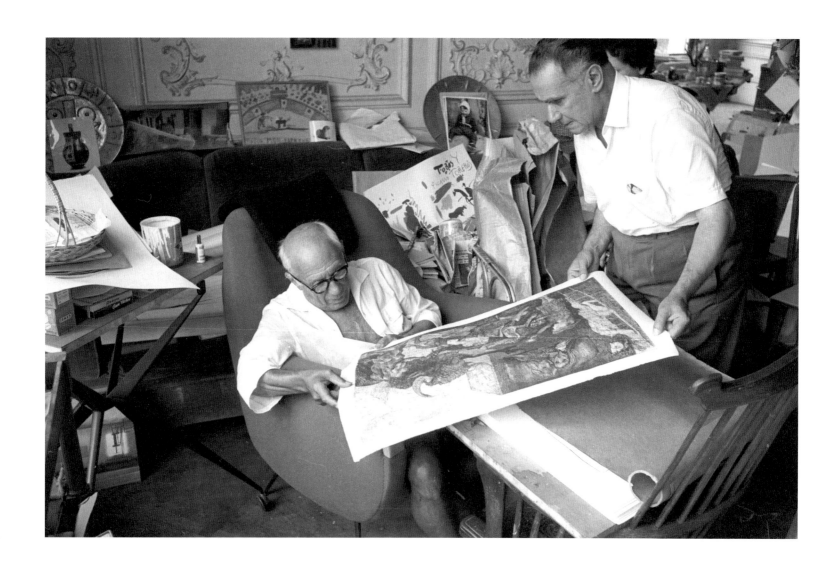

Picasso inspecting an impression of *La Minotauromachie*
with the art dealer Henri Matarasso, 'La Californie', Cannes, 1961
Photograph by Edward Quinn

Picasso, his Prints and his Printers

Pablo Picasso (1881–1973) was an obsessive draughtsman and printmaker. He made at least 2200 prints in all kinds of techniques: the first dates from 1899, when he was seventeen, the last from 1972, when he was ninety. The number of drawings he made is so vast it has never been properly counted. His passion for drawing seems to have begun in infancy. His biographer Roland Penrose tells us that Picasso's first words were 'piz, piz' – a demand for lapiz, the Spanish word for pencil – and that he could draw long before he could speak.[1] These biographical details are probably fanciful, but Picasso certainly was a compulsive, skilled and intuitive draughtsman from an early age. This was partly due to the influence of his father, who was an art teacher. He passed the drawing exams at the Llotja art school in Barcelona when he was just fourteen, and while Penrose exaggerated when he said that Picasso completed a month's programme of exams in a single day, there can be no doubting his incredible precocity.[2] Picasso's closest and longest-serving friend, Jaime Sabartés, tells us that as a student in Barcelona, Picasso would return to his studio and paint and sketch ceaselessly: 'To this day, I remember him lost in a mountain of papers.'[3] Sabartés also tells us that Picasso kept warm on cold winter nights by burning the sketches in the fireplace: 'This may seem an exaggeration, considering how easily paper is consumed by fire. But Picasso was producing without rest, in a sort of delirium.'[4] While he was still a teenager, he had drawings published in Catalan journals, made posters, and once he had left the family home, sent news to his family not in the form of letters, which he disliked writing, but as pictorial news-sheets with captioned illustrations. He also held exhibitions. The most important of these, held at the Els Quatre Gats bar in Barcelona in 1900, when he had only just turned eighteen, featured as many as a hundred portrait drawings. This passion for drawing was inbuilt, but it was also steered by two economic considerations: in the first place drawings were cheap to do, and in the second they were easier to sell than paintings, particularly if they were flattering *moderniste* portrait sketches of the type he specialised in at this time.

One feature which characterises Picasso's art and approach, throughout a career spanning eighty years, is his flexibility and creative response to new situations. His most celebrated saying 'I do not seek, I find' could be taken as a mission statement for his printmaking in particular. He had no formal education as a printmaker and picked up techniques as he went along, enjoying the company of technicians who could teach him new skills, which he then adapted to his own requirements. He made a fundamental mistake with his first print, an etching of a picador done when he was living in Barcelona in 1899. He forgot that the process of etching made the image come out in reverse, and therefore unwittingly produced a picador holding his lance in his left hand. Rather than rework the image, Picasso made a virtue of his

mistake, entitling the print *The Left Hander* [*El Zurdo*]. This was probably the only print he ever titled: the rest were given titles by dealers and art historians to distinguish one from another. Picasso also made a mistake with his second etching, the remarkable *The Frugal Meal*, which he produced in Paris in 1904 (cat.2). Lacking the money to buy a new etching plate, he simply borrowed an old one from a friend and polished out the previous image before making his own. However, he seems to have been too impetuous to do the job properly as in places he left part of the earlier landscape showing through. Close inspection shows that tufts of grass sprout from behind the woman's head. Picasso, never one to look back, simply left it and moved on to the next project. Just as he started making sculpture around this time, thanks to help offered by Spanish sculptors who lived nearby, in and around the Bateau Lavoir studios in Montmartre, so he took advice from fellow Spanish artists in making these early etchings. Unable to afford to work in a professional printer's workshop, he etched the prints in his own cramped little studio.

Picasso began making prints in earnest in 1905, producing more than a dozen etchings that year, mainly on the theme of travelling circus figures. With the exception of a few woodcuts, all Picasso's prints from these early years in Paris were either etchings or drypoints. Etchings are made by drawing into a thin wax surface on a metal plate and then biting the lines with acid which etches into the plate. The drypoint technique involves scratching into the metal plate itself: this produces a richer black line when the plate is inked and passed through the printing press. Picasso used small copper plates, which were all he could afford, and had just a few of each printed by Auguste Delâtre (1822–1907), an elderly artist-printer who had a workshop on rue Lepic in Montmartre. They were marketed through the dealer Clovis Sagot, but sales were slow. Picasso seems to have made very few prints between 1906 and 1909 (hardly any still exist, anyway), but he was sufficiently interested in printmaking to acquire a small press of his own, which he bought from the printer Louis Fort in 1907.[5] Famously impatient to see his plates printed as quickly as possible, he used the press to pull individual proofs of his etchings.

In September 1911 the dealer Ambroise Vollard bought nearly all the etchings Picasso had made in 1904 and 1905: two years later he published them as the *Saltimbanque Suite* in unusually large editions of 250 copies of each. There were fourteen plates, so Vollard's preferred printer, Louis Fort, had to print 3,500 separate etchings – an indication of Picasso's growing reputation, or at least Vollard's faith in his young protégé. The edition was so vast that the copper plates had to be steel-faced, otherwise they would have worn out. Vollard was not particularly keen on Picasso's Cubism, preferring the more commercial early work.

The dealer Daniel-Henry Kahnweiler exploited that blind spot in Vollard's taste and commissioned or published most of Picasso's cubist prints, including his first important book project, illustrations for Max Jacob's *Saint Matorel* (cat.10). Most of these cubist etchings were printed by Eugène Delâtre (1864–1938) who took over the family business when his father Auguste died in 1907. By this date Picasso's profile was high. He was acquiring international fame as the inventor of Cubism, and was attracting the interest of dealers and collectors from across Europe and America. In 1912 he moved from Montmartre to more spacious accommodation in Montparnasse, in the south of Paris.

During the First World War, Picasso, the undisputed leader of the avant garde, seemed to take a backwards step. He began making very realistic drawings and these soon became the talk of Paris. Some of his followers called it a betrayal; others followed suit. Picasso worked in this more traditional style alongside his cubist work, and sometimes combined the two approaches. Influenced by classical art (a trip to Italy in 1917 had made a big impression on him), and the drawings of Ingres and paintings by Renoir, in the 1920s he drew and painted massive, heavy-limbed nudes. Whereas Picasso's paintings of this period tend to concentrate on one or two figures, in his drawings he produced more elaborate, multi-figure compositions, as in *Group of Female Nudes* (cat.15). Picasso made his first lithographs around this time. Lithographs are made by drawing with a waxy crayon onto a heavy lithographic stone or a zinc plate, and when the surface is inked, it sticks to the crayon marks. The technique seems not to have fired Picasso's imagination: he simply used it as a way of making printed versions of his drawings (cat.16). Only later, after the Second World War, would he return to lithography and exploit it as a creative medium that could give him effects that were unobtainable in drawing.

Chance was a major factor in driving Picasso's printmaking forward. Commissions, changes in circumstance or simply moving house, obliged him to work in different ways. In the late 1920s and early 1930s he was commissioned to make illustrations for a number of book projects, notably Balzac's *Le Chef-d'oeuvre inconnu* (cat.18), Ovid's *Metamorphoses* and the one hundred etchings which became the *Vollard Suite* (cats.23–33). Illustration is actually the wrong word as Picasso never followed a text closely. Instead, he would pick up on a theme and then worry away at it until he was moving in another direction entirely. Hitherto, Picasso's paintings, drawings and prints had followed a similar path. But from the late 1920s, when he devoted more time to printmaking, they began to diverge. Working on a smaller scale and in reverse, he felt able to introduce new subject matter. Much of the subject matter is autobiographical, but is hidden in the form of alter egos, notably the Minotaur and

the figure of the bearded sculptor in the *Vollard Suite*. Etchings could also be made very quickly, and this allowed Picasso to develop images in sequence, almost like frames from a film. Freed from concerns about composition, colour and scale, this sketchbook approach enabled him to create loose narratives.

Picasso was still an inexperienced etcher at this point and he worked primarily in the fine, linear, neoclassical manner which had developed from his earlier, realistic portrait drawings. The etchings for *Le Chef-d'oeuvre inconnu* and the *Vollard Suite* were executed in this style, with occasional use of cross-hatching to give the effect of three-dimensional form (cats.27–8). Picasso simply etched the copper plates at his studio and had them printed up by Louis Fort. By this time, Picasso was becoming increasingly interested in the techniques of printmaking, to the extent that he had printing equipment installed in the stables of his château at Boisgeloup, north of Paris, in the early 1930s. He was not a skilled printer, but this did not worry him. Some of the works he printed himself are, by a professional's standards, flawed. In *Bathers with a Balloon II* (cat.20) he etched the plate too deeply, having probably left it in the acid bath too long. The lines are full of bubbles and marks, but this was not the sort of thing Picasso bothered about. He apparently used nail varnish and suet to obtain other effects.[6] In some of the earlier *Vollard Suite* prints he also tried to achieve a tonal effect, seemingly with a very broad etching needle, but the results were not wholly successful (cat.24). Even in *Blind Minotaur Guided in the Night by a Young Girl with a Pigeon* (cat.31), which employs a mixed etching technique, Picasso struggled to achieve a rich tonal quality.

Picasso needed help. He evidently wanted to achieve novel effects but did not know how to go about it. It was only while working on the *Vollard Suite* that his field of vision expanded, thanks to an encounter with Roger Lacourière (1892–1966). Lacourière's father and grandfather had both been printer-engravers. He opened up his own etching and engraving workshop on the rue Foyatier in Montmartre in 1929. According to Brigitte Baer, Picasso and Lacourière met early in 1933, when Picasso happened to be passing the printer's studio and went in to have a look.[7] Others say that it was Lacourière who got in touch with Picasso the following year, with the intention of making quality reproductions after his paintings (this was the area Lacourière specialised in at the time).[8] Whatever the case, it seems that they did not start working together until the latter part of 1934, when Lacourière introduced Picasso to a variety of new etching techniques, including spitbite, burin, sugarlift and sophisticated aquatint effects. Picasso had used aquatint in some of his cubist etchings, but never to any great degree. With aquatint the artist can produce tones rather than lines. It involves covering the etching plate with a powdery kind of resin, immersing the plate in acid, and letting the

acid etch into the metal around each miniscule grain. When inked and printed, the treated areas print as grey half-tones. Spitbite and sugarlift are aquatint techniques which, as their names imply, involve the application of saliva and sugar to achieve particular effects. Using these and other techniques, Picasso was able to create more painterly, tonal effects, as seen in *Faun Unveiling a Sleeping Woman* (cat.32). The collaboration between Picasso and Lacourière reached its peak in the *Weeping Woman I* etching of 1937 (cat.39). For an artist who was notoriously impatient to see the final results almost instantly, the collaboration was a godsend. Lacourière would prepare the copper plates and then print them up as soon as Picasso had finished. Jaime Sabartés described the process of work at Lacourière's studio: 'He [Picasso] had time to order copper plates which he engraved one after another with no thought other than to solve difficulties, to make innovations, to try out the superimposition of various inks … to obtain hues as fresh as if he were working with a brush, to scrape whenever he deemed it necessary, to find the grain which would produce such and such an effect.'[9] Working at Lacourière's studio well into the night, Picasso could produce prints cyclically, building on the imagery he had put into each previous plate. The printing process gave each work an homogeneity and authority that was difficult to achieve through drawing, yet it did not require the careful planning usually demanded of painting.

Just as Picasso had come across Lacourière by chance, and had a whole new world of printmaking possibilities open up to him, so the same happened with lithography. Towards the end of 1945 the lithographer Fernand Mourlot (1895–1988) invited him to make some prints. Like Eugène Delâtre and Lacourière, Mourlot had printing in his blood: his father, Jules, was a celebrated lithographic printer. The introduction may have come through the artist Georges Braque, who had already worked with Mourlot. Françoise Gilot, Picasso's lover during these years, recalled that the collaboration developed by chance rather than by design. In the immediate aftermath of the Second World War, Picasso became plagued by casual visitors and dealers who would turn up at his studio on the rue des Grands-Augustins in the centre of Paris and demand to see him. Mourlot's print studio in the rue de Chabrol, in an unfashionable area near the Gare de l'Est, offered a kind of refuge.[10] Gilot described it as 'a dim, cluttered, ramshackle place, full of piles of posters, lithographic stones and general confusion … It was almost like a scene from Daumier, all black and white.'[11] That sort of old-fashioned, messy studio would have appealed to Picasso. Moreover, it was heated, which was rare among print studios in the immediate postwar period. Mourlot moved to lighter, more spacious premises in the rue Barrault in 1960, but even this workshop had a Victorian feel to it. For four months, Picasso worked there almost daily. Mourlot taught him everything he

Fernand Mourlot and Françoise Gilot, *c*.1968
Photographer unknown

15

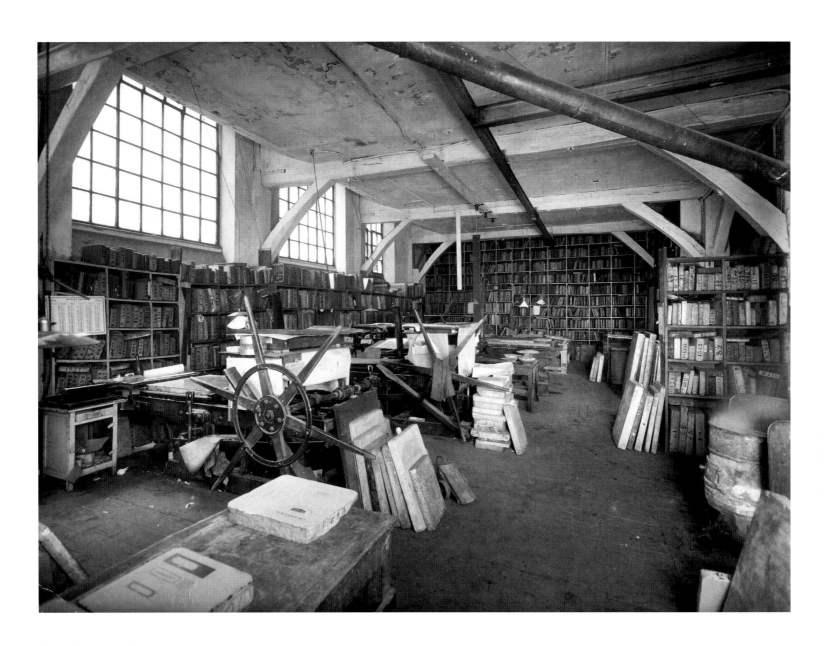

The Ateliers Mourlot,
rue Barrault, Paris, *c.*1960
Photograph by Chevojon

knew and recalled that while Picasso observed his instructions patiently, he did not follow them: 'He looked, he listened, he did the opposite of what he learnt, and it worked.'[12] Mourlot's assistants were equally baffled and impressed: 'We gave him a stone and two minutes later he was at work with crayon and brush. And there was no stopping him. As lithographers we were astonished by him … And he would scrape and add ink and crayon and change everything! After this sort of treatment the design generally becomes indecipherable and is destroyed. But, with him! Each time it would turn out very well.'[13] Picasso was equally irreverent when it came to tools, preferring a little pocket knife instead of the specialist *grattoir* tool which the lithographers recommended.

Etching is like sketching while lithography is more like painting. Whereas the linear character of the etched line had provoked Picasso into producing narrative scenes, often bound up with myth and mythology, with lithography he frequently worked on portraits. This connected with his personal life. It is often said that Picasso's art changed when his lovers changed, and the arrival on the scene of the young Françoise Gilot, whom he met in 1943, seems to have brought about this new interest in portraiture, as well as this new interest in lithography, which she encouraged. Instead of simply using the lithographic crayon, as he had done in the 1920s, he began working with a lithographic paint called 'tusche', which is applied with a brush. With etching, it is often difficult to tell what the final print will look like; but with lithography the artist sees the image more or less as it will appear (in reverse) on the printed paper. It is also easier to erase, amend and rework the image. The flexibility of the lithographic process appealed to Picasso, resulting in some of his most fabulous, emblematic images, particularly the portraits of Françoise, which he made in the late 1940s (cats.50 and 58–60). At first he used the more conventional and traditional lithographic stones to make these prints. Later, he used zinc plates: these were bigger, allowing him to make bigger prints, and they were also lighter, so he could take them home and work on them in his own studio at night. He also used transfer papers, whereby he drew directly onto the paper and the image was subsequently transferred onto the lithographic stone. This is a double reverse process, so the image comes out the way the artist originally drew it. The collaboration with Mourlot resulted in about 400 lithographs.

If etching had encouraged Picasso to work in sequence, this was equally true of lithography. With both techniques, the artist can make an image, print it, then erase parts of the plate and rework it. Picasso liked to do this with lithographs, and the prime example is the series of eleven bulls, made between December 1945 and January 1946 (cat.48). Metamorphosis was central to Picasso's art. He loved the way a guitar could double up as a female

The printing press and lithographic stones, Ateliers Mourlot, *c*.1960
Photograph by Franck Bordas

nude or the way a bottle could be transformed into a head with the addition of a few pencil marks. Many of his paintings went through complicated transformations, but he could only record those changing states photographically (Dora Maar's photographs of the evolution of Picasso's *Guernica* are a classic example). In one of his rare statements made in 1935, Picasso acknowledged that his work was achieved through a process of reduction: 'In the old days pictures went forward towards completion by stages … A picture used to be a sum of additions. In my case a picture is a sum of destructions. I do a picture – then I destroy it … It would be very interesting to preserve photographically, not the stages, but the metamorphoses of a picture.'[14] With printmaking, and particularly with lithography, Picasso could hold on to each stage of that transformation and thereby disclose the magic and mystery of his own creative process. His passion for precisely dating every drawing and print relates to this and the dates enable us to follow the development in sequence. With *The Bull*, Picasso got Mourlot to take impressions every few days, before he returned to the stone to rework it. The final sequence of images shows the gradual transformation of a bull as it turns from a massive beast into a few schematic lines.

After the Second World War, Picasso spent increasing amounts of time in the south of France. On their first trip, he and Françoise stayed with the elderly printer Louis Fort, who had by then settled at Golfe-Juan, near Antibes. Then in 1948 Picasso bought a villa at nearby Vallauris. Etching and lithography became more difficult to practise. Both techniques involve specialist equipment and specialist printers, and in the south he did not have that kind of help to hand. There were ways around this: a printer could travel down from Paris with the plates, wait for Picasso to make some images, return north, print them up, and then send them back for Picasso to check. This happened with a number of projects (*Le Chant des morts* for example, cat.53) and Picasso's son, Paolo, who was a keen driver, often did the courier work. The photographer David Douglas Duncan visited Picasso in 1957 and observed him at work on some of the plates: 'One dull rainy afternoon a few days after the Arles Easter corrida, Picasso sat alone at the dinner table which had often served as a studio accessory, and in three hours painted twenty-seven aquatint copper plates.'[15] It is no wonder that Picasso got frustrated with etching when he was producing works in such number but had to wait months or even years to have them printed.

However, near his home in Vallauris Picasso encountered a local man, Hidalgo Arnéra (1922–2007), who specialised in printing newspapers and posters. When in 1951 Picasso was asked to make a poster to advertise the town's annual art exhibition, Arnéra suggested he make it in linocut, which is relatively easy to cut and print and can easily accommodate text.

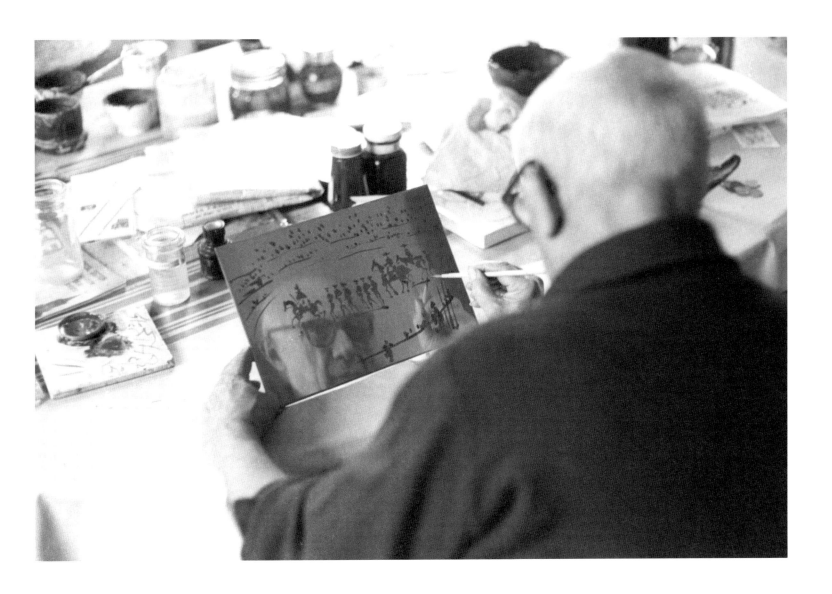

Picasso painting *Paseo de Cuadrillas*
on a copper plate, 'La Californie', Cannes, May 1957
Photograph by David Douglas Duncan

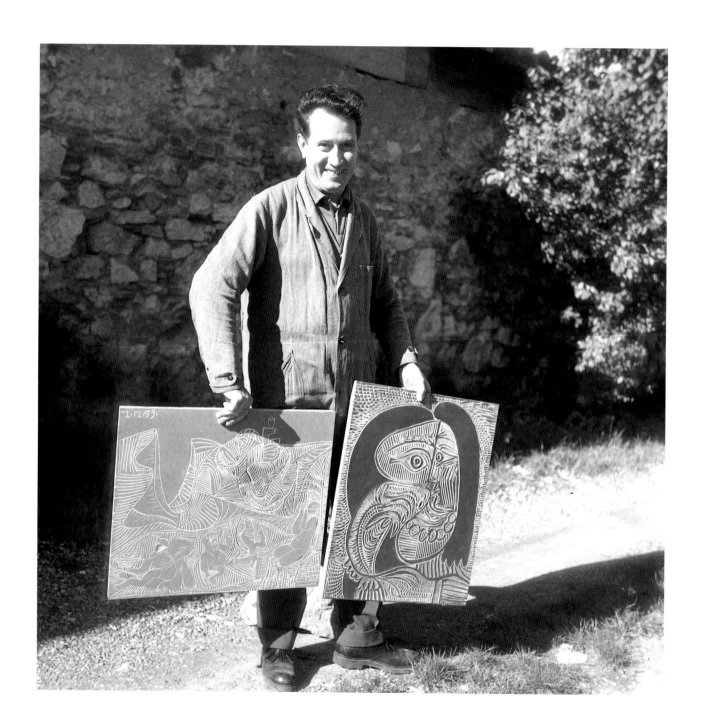

Picasso followed his advice and made other linocut posters in the early- and mid-1950s, some of them advertising local bullfights. The earliest ones were done in single colours, and then he began using simple colour overlays. His first independent linocut was *Portrait of a Young Girl, after Cranach the Younger*, made in 1958 (cat.78). It is a technical *tour-de-force*, but Picasso found the business of cutting separate pieces of linoleum tedious and complicated (the artist has to cut as many pieces of lino as there are colours in the print, and make sure they all match up properly). Typically, he got round the problem by inventing a new technique, using a single piece of linoleum which he cut, printed, then re-cut and reprinted, always using the same piece of linoleum (see cats.79–83). Arnéra recalled Picasso's regular working pattern at this time. Picasso would make the linocuts late at night and then his chauffeur would take them around to Arnéra's workshop first thing in the morning. He then printed them up (often a complicated task as he had to mix inks in a very particular way so that the different colours overprinted properly) and at 1.30pm precisely would take them to Picasso's home for judgement. Arnéra did this every day, except weekends, for eight years, eventually making some 200 linocuts.[16] Always keen to obtain new effects, Picasso even invented a new

opposite: Hidalgo Arnéra holding two of Picasso's linocut blocks (*Bacchanale with Owl* and *Woman with Necklace*), probably December 1959
Photograph by Edward Quinn

right: Picasso's tools for making linocuts lying on top of the linocut *Portrait of a Family*, probably June or July 1962
Photograph by Edward Quinn

technique which involved rinsing the linocut in the shower (cat.84). Picasso liked to get his hands dirty and insisted upon doing this himself. Commenting on Picasso's approach to printmaking, Arnéra said: 'he had a sort of aggressive delight in encountering an obstacle and surmounting and conquering it. Difficulty, moreover, by providing experience, gave him a jumping off point from which to conquer fresh fields.'[17]

In the 1950s Picasso had continued to make lithographs and etchings, doing so on periodic trips to Paris, or when one of the Paris printers ventured south to help. In 1955 Lacourière retired, allowing his chief assistant Jacques Frélaut to take over the business. Frélaut helped Picasso with his etchings from this point, making several trips to Picasso's château 'La Californie' in Cannes. Another printer who helped out during these years was Aldo Crommelynck (b.1931). Crommelynck had begun working in Lacourière's etching workshop in 1948 and as a teenager had impressed Picasso with his skills. With his brother Piero (1934–2001), he set up his own printing studio in Montparnasse in 1955. However, working with Picasso proved almost impossible because he lived at the other end of France. Since Picasso would not come to Paris, Aldo and his brother came up with the obvious solution: they would move south. In 1963 they set up an etching studio in the village of Mougins, north of Cannes, where Picasso was then living. Thus began the last, the most productive and the most startling phase of Picasso's printmaking activity. Aldo later recalled: 'It was a very small studio and I performed every function ... I had to do everything myself, commuting between the print studio in the village of Mougins and Picasso's studio about a mile and a half outside of town. I would prepare the plates to proof which is inevitably a messy job ... then I'd deliver the proofs to Picasso and pick up new plates, returning to the studio to proof them – we often worked until after midnight ... It was a lot of work but I was always available, that was the condition.'[18] On some days Picasso would make as many as eight etchings. Piero Crommelynck became such a part of Picasso's life that he became one of the stock figures in Picasso's drawings and prints (cat.88). Picasso used every technique in the book, and invented more besides. Some involved wiping his fingers on the plate – heresy as far as most professional printers were concerned; others involved petrol.[19] In total, about 500 etchings resulted from this collaboration (cats.85 and 89–91). Aldo later noted: 'It was a real pleasure to work with Picasso. It was known to the people around him that when he dedicated himself to printmaking, he was in a good mood. [...] but when he was in a painting sequence, he didn't want to see anybody. Drawing on the etching plate was a very casual process for him. After the meal, lunch or dinner, but preferably late at night, he would take a small plate and work on it at the table, resting it against his knee.'[20] Roland Penrose also

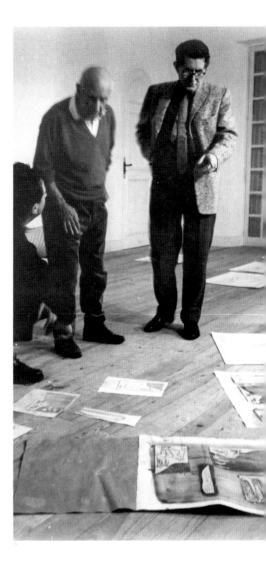

Picasso and Roland Penrose surveying Picasso's washed linocuts, Mougins, c.1963
Photographer unknown

Picasso creating a washed linocut, Mougins, *c*.1963
Photograph by Edward Quinn

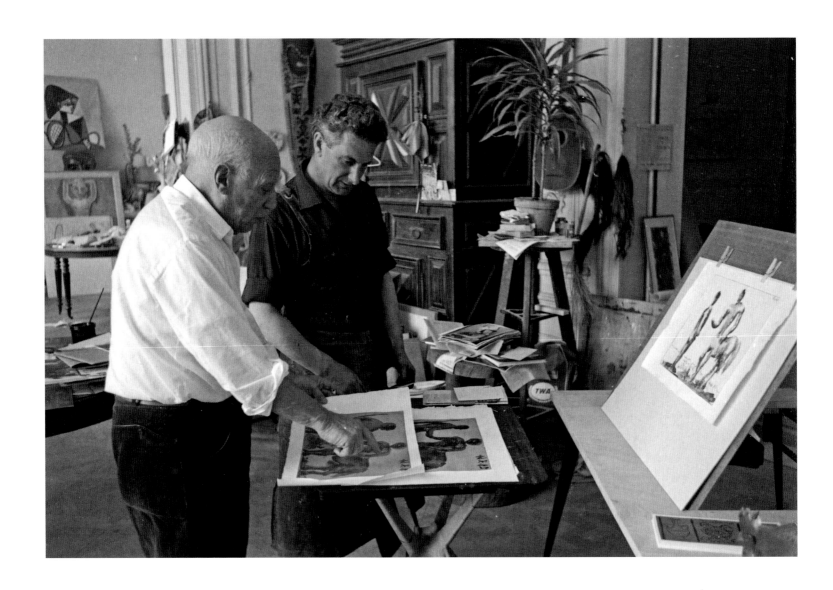

Picasso and Jacques Frélaut checking a proof
of the aquatint *Centaur and Man with a Staff*,
'La Californie', Cannes, March 1957
Photograph by Edward Quinn

noted Picasso's passion for printmaking in these final years, observing, during a visit to Mougins in the early 1970s: 'Engravings absorb him entirely. Drawings happen more often when he is also painting. Aldo has noticed that a period of engravings often precedes a burst of painting – Picasso seems to feel greater freedom and scope for experiment in graphics – more so than with drawing.'[21]

For Picasso, new printing techniques were like new lovers. They inspired him to take new approaches and renew his creative instincts. During his life he became obsessed with half a dozen women and he also became obsessed with half a dozen printing techniques. Extending that analogy, he tired of lithography and linocut in the same way that he tired of the same female company. For Picasso, art and love were equal partners in the creative process. It is no accident that art and love were also the chief subjects of his work – or rather subject, for he very often combined the two.

From left to right: Roland Penrose, the publisher Gustavo Gili, Piero Crommelynck, Aldo Crommelynck, and Picasso, checking a proof copy of *Seated Man with Pipe, Maja and Célestine, c.*1969–70
Photograph by Lucien Clergue

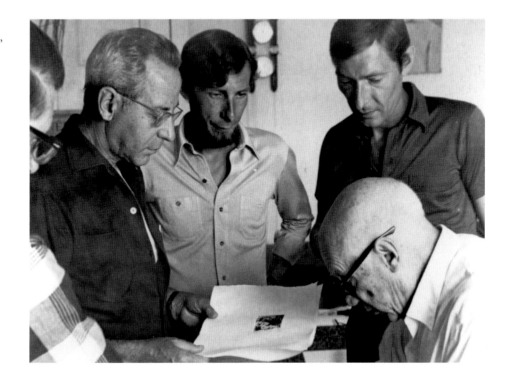

Catalogue

Unless otherwise stated,
all works are on paper. Measure-
ments are in centimetres, height
before width.
Bibliographic references can
be found on pp.143–4.

1
Going to the Fair, c.1899

Pastel and watercolour, 21 × 33cm
University of Edinburgh Fine Art Collections

This striking early work does not feature in the
literature on Picasso. It belonged to Charles and
Hope Montagu Douglas Scott, Scottish collectors
who bought it from the O'Hana Gallery in
London in 1960. Hope Montagu Douglas Scott
bequeathed it to the University of Edinburgh in
1990. It dates from Picasso's time in Barcelona in
1899 or possibly early 1900, before he left for
Paris in October of that year. The style is
reminiscent of Theophile Alexandre Steinlen's
drawings, which had a strong influence on
Picasso in these early years. A related water-
colour, showing two figures on a horse, is in the
Museu Picasso, Barcelona (MPB.110.840).

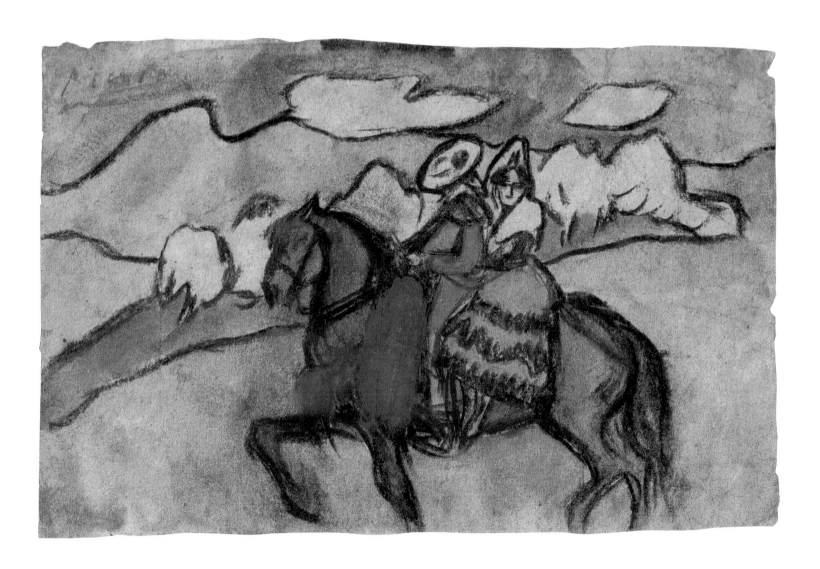

2

The Frugal Meal, 1904

[Le Repas frugal]
Etching, 46.3 × 37.7cm plate;
63.3 × 47.3cm sheet
Staatsgalerie Stuttgart, Graphische Sammlung
Inv. A 13/165

Picasso made his first etching, *The Left Hander*, in 1899, when he was living in Barcelona. *The Frugal Meal*, made in September 1904 when Picasso was twenty-two years old, was only his second etching but it remains one of his most celebrated. Picasso had no formal training in printmaking and made these first prints with the help of his friend the artist Ricard Canals. *The Frugal Meal* was executed on an old zinc plate, previously used for a landscape etching by Joan González, a Spanish artist (and brother of the sculptor Julio González) who lived in the Bateau Lavoir studios in Paris, alongside Picasso. Canals and Picasso were not thorough in scraping down González's old plate: tufts of grass in the earlier etching can still be seen in the top right area of Picasso's print.

The Frugal Meal relates to several of Picasso's Blue Period paintings, which dwell on the themes of poverty, alcoholism, misery and blindness: here, the male figure seems to be blind. Blindness – an emotive subject for any artist – preoccupied Picasso, partly, it is said, because it was associated with venereal disease and Picasso was fond of brothels. The style of these works derives partly from El Greco and the subject matter of a frugal meal is also typically Spanish. It is also an early example of a theme which would recur throughout Picasso's graphic work: the pairing of male and female figures. Brigitte Baer notes that the two figures are retrogressive in style, in that they recall works Picasso had made the previous year (Baer 1986–96, vol.I, p.20). It may be that Picasso used a tested formula and a bravura etching technique in the hope of generating some income.

The Frugal Meal was printed by Auguste Delâtre in an edition of about thirty; copies were marketed by the dealer Clovis Sagot but did not sell well. In September 1911 the dealer Ambroise Vollard bought the plate and fourteen others

mainly of circus themes. In 1913 he had them steel-faced (to make them more durable) and printed by Louis Fort in ambitiously large editions of 250 copies of each, plus a few more on special papers. One of the smaller, less resolved etchings was removed, bringing the total number of prints in the suite to fourteen. The suite was marketed under the title *Les Saltimbanques*, even though several of the etchings, including this one, had nothing to do with saltimbanques. This work and cat.4 were acquired by the Staatsgalerie Stuttgart in 1913, the year they were printed. Unfortunately the Staatsgalerie's records were destroyed during the Second World War, so the acquisition details are unknown.

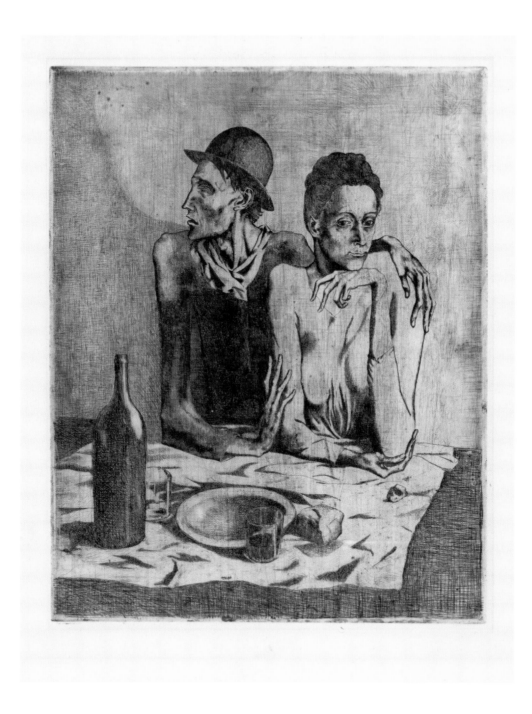

3
Head of a Woman: Madeleine, 1905

[Tête de femme: Madeleine]
Etching, 12.1 × 9cm plate; 50.8 × 33cm sheet
Staatsgalerie Stuttgart, Graphische Sammlung
Inv. D 46/75

Made in January 1905 and traditionally entitled
'Madeleine', this was Picasso's third etching.
Madeleine (her surname is unknown) was a
married woman and artist's model who became
Picasso's girlfriend in 1904. However, John
Richardson has identified the sitter as Fernande
Olivier (1881–1966): by the summer of 1904 she
had become Picasso's mistress and she remained
so for seven years (Richardson 1991, p.315).
Richardson notes that Fernande had a full face
and figure, but that here Picasso gave her the
emaciated look which is characteristic of his Blue
Period paintings – to such an extent that she
resembles Madeleine, who was thinner. Unlike
The Frugal Meal (cat.2) which was executed on a
zinc plate, this work was etched on copper.
Copper plates were more expensive, and this may
account for the small size of the print. Like cats.2
and 4, it was published in 1913 as part of the
Saltimbanque suite.

4

Mother Arranging her Hair, 1905

[La Toilette de la mère]
Etching, 23.5 × 17.7cm plate; 51.1 × 32.9cm sheet
Staatsgalerie Stuttgart, Graphische Sammlung
Inv. A 13/166

Picasso's shift away from the misery of the Blue Period towards an iconography based on the circus and the *commedia dell'arte* was inspired by the poet and critic Guillaume Apollinaire (1880–1918). Picasso and Apollinaire first met in 1904. During 1904–5 Apollinaire became obsessed with the themes of the harlequin and acrobats. Picasso made thirteen small etchings mainly of acrobats and circus figures in 1905 and John Richardson believes that they may have been conceived as illustrations for a book of Apollinaire's poems (Richardson 1991, p.334). The publication of the poems was delayed until 1913, by which time Picasso had already sold the plates to Ambroise Vollard for independent publication, otherwise, the poems and etchings might have been published together. In the spring of 1905 Picasso made a gouache painting of a very similar scene to the present etching, *The Harlequin's Family* (Private Collection). Many of Picasso's paintings of this period were executed in pinky hues, hence the term Rose Period for the work of 1905.

5
The King, 1905

[Le Roi]
Pastel, 55 × 46cm
Staatsgalerie Stuttgart, Graphische
Sammlung
Inv. 2353

The Staatsgalerie Stuttgart formerly
catalogued this drawing as *Le Roi
Dagobert* (King Dagobert was a seventh-
century Frankish king) but that title is
apocryphal. Instead he seems to be a
Saltimbanque king. A related drawing in
the Musée Picasso, Paris (MP.501), shows
the same bearded figure, seated on a
chest and gently embracing a young
woman who also wears a crown. That
crowned young woman reappears, this
time breastfeeding, in a drawing in the
Tate collection (T03571). Another ink
drawing in the Pushkin State Museum
in Moscow, shows a king wearing a
much more elaborate crown. The mean-
ing of this small series of drawings is
unknown. They may well have been
studies for a painting which Picasso
never undertook.

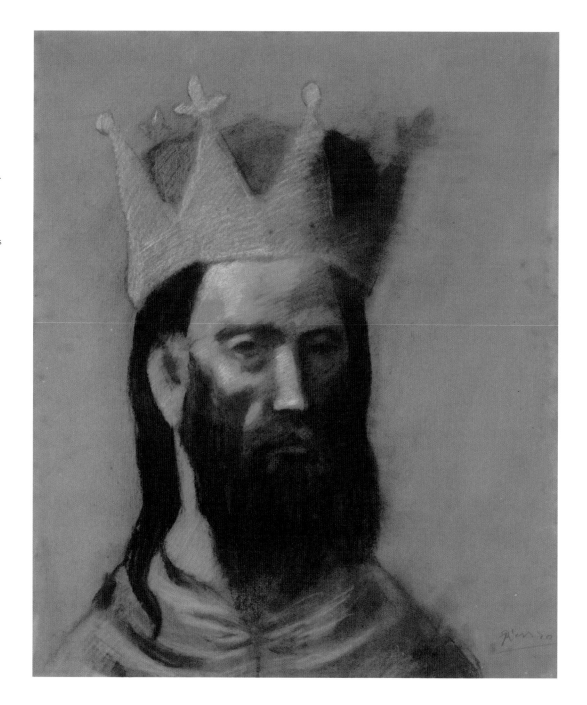

6

Seated Nude, 1906

[Nu assis]
Charcoal, 47.4 × 29.4cm
Staatsgalerie Stuttgart, Graphische Sammlung
Inv. GL 322

This outstanding drawing demonstrates the giant leap Picasso made between 1905 and 1906, when he moved on from the emaciated and androgynous circus performers of his Rose Period and instead introduced figures which have greater mass and weight. The various influences behind this shift are well charted: they include the great Ingres retrospective of 1905, Picasso's interest in Puvis de Chavannes and Gauguin, his chance discovery of archaic Iberian sculpture at the Louvre and his renewed interest in making sculpture. The shift coincided with a trip to Gósol in Spain, where he spent the summer of 1906. There his Rose Period figures began to get weightier, and their faces became mask-like. When he returned to Paris, he repainted the portrait of the American writer Gertrude Stein which he had already spent some months working upon. He now gave her a stylised, mask-like face, and introduced that style into other paintings and drawings. This drawing probably dates from autumn 1906, when he was back in Paris, reworking Gertrude Stein's portrait. A closely related drawing is in the Musée Picasso, Paris (MP.521).

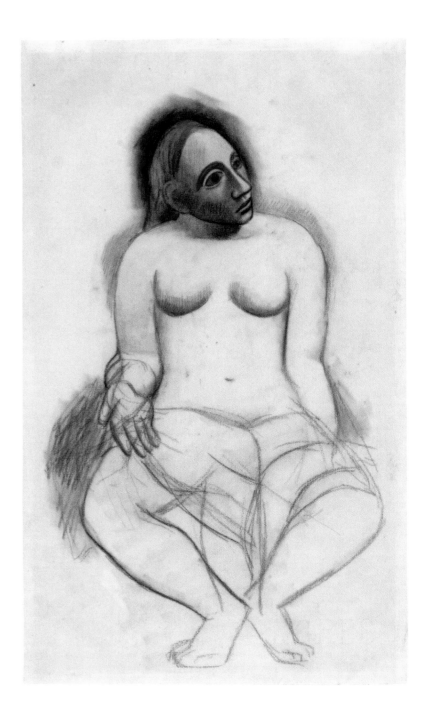

7
Study for Standing Nude, 1908

[Etude pour nu debout]
Pen and ink, 31.5 × 23.7cm
Staatsgalerie Stuttgart, Graphische Sammlung
Inv. c 59/889

In 1907 Picasso painted *Les Demoiselles d'Avignon* (Museum of Modern Art, New York). The painting revealed Picasso's new interest in African tribal sculpture and his growing tendency to treat foreground and background as a single entity. In subsequent works of 1907–8 – such as this drawing – it is often difficult to disentangle the figure from the surrounding space. *Study for Standing Nude*, which dates from around spring 1908, is a study for a painting now in the Museum of Fine Arts in Boston. It also relates to a group of paintings, watercolours and drawings, which feature a female figure raising her left arm behind her head. These studies were part of a projected composition, subsequently abandoned, showing several nudes at the edge of a forested lake, with a figure similar to the nude in the present drawing stepping into a boat. The hatched lines which Picasso used in drawings and paintings around this time owe something to Cézanne, who died in 1906 and whose retrospective exhibition, staged at the Salon d'Automne in 1907, proved crucial to the Parisian avant garde. Cézanne's late bather compositions also had a major impact on Picasso in terms of his subject matter.

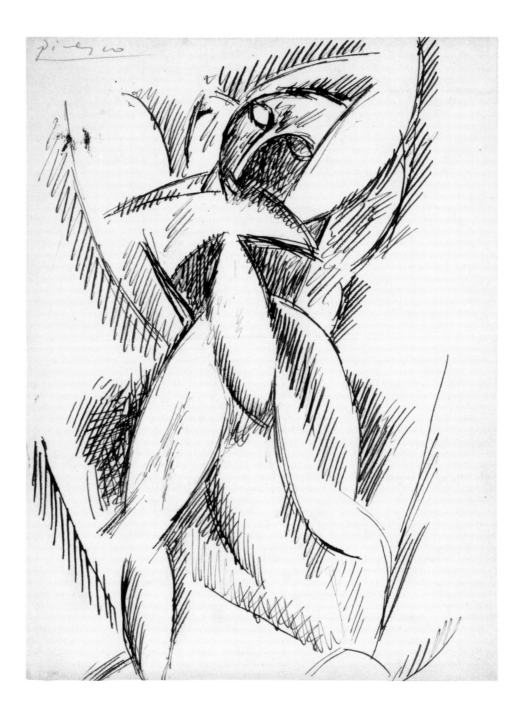

8
Two Nude Figures, 1909

[Deux figures nues]
Drypoint, 13.1 × 11cm plate; 60.7 × 44.2cm sheet
Scottish National Gallery of Modern Art
GMA 3008; purchased 1986

Picasso seems to have made just one etching in
1906 and then none again until he made this
work in spring 1909. It is a drypoint – an etching
technique in which the artist scratches directly
into the copper plate with a needle, instead of
normal etching, which involves scratching into a
wax layer on top of the copper and etching into
the metal with acid. The unusual subject – a
young boy presenting a cup or chalice to a seated
female nude – has never been explained. Around
1908 Picasso made several sketches of a figure
presenting another figure with a cup or similar
vessel (Musée Picasso, Paris: MP.1863, 65–68).
These seem to be studies for a major composition
which was never completed. Picasso's fellow
cubist artist Georges Braque included mandolins
in a number of his paintings dating from 1908
onwards, and Picasso treated them from 1909:
one of these paintings shows a similar composi-
tion, but without the boy (Daix 1979, no.235).
If a specific narrative was intended by Picasso we
no longer know what this was. This drypoint was
printed by Eugène Delâtre and published by
Daniel-Henry Kahnweiler in 1912 in an edition
of one hundred.

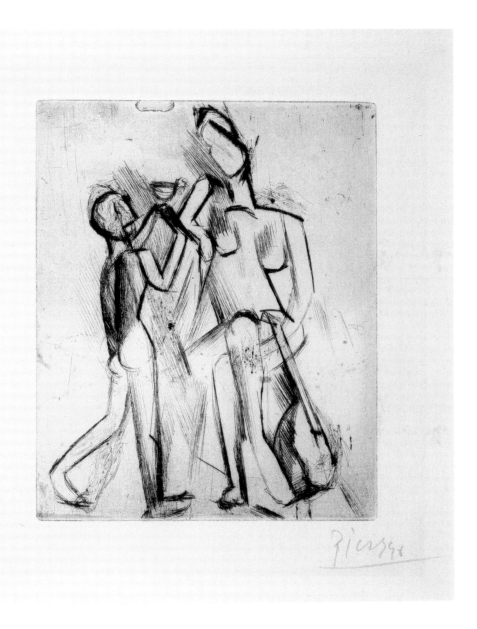

9
Nude, 1910

[Nu]
Pen and ink, 31.5 × 20.9cm
Staatsgalerie Stuttgart, Graphische Sammlung
Inv. c 66/1438

This drawing probably dates from the summer of 1910, when Picasso was staying at Cadaqués, on the Costa Brava in Spain. Working there throughout July and August, he began to abandon obvious figurative references and open up the closed form of the body, allowing space and solid forms to interpenetrate and the graphic marks of lines and curves to take on their own logic. Little figurative references remained: in this drawing we can decipher the buttocks, the breasts and the curve of the leg, and these in turn tell us that this is a standing figure – but otherwise the drawings of this period seem abstract and austere. The way in which we can see different sides of the figure simultaneously was explained by contemporaries in terms of mobile perspective, as if Picasso had been moving around the figure as he drew it. Picasso himself remained silent about the impulse or meaning behind his cubist work. It is one of a series of eight drawings which seem to be preparatory studies for the large painting *Nude*, now in the National Gallery of Art, Washington (see Karmel 2003, pp.78–9).

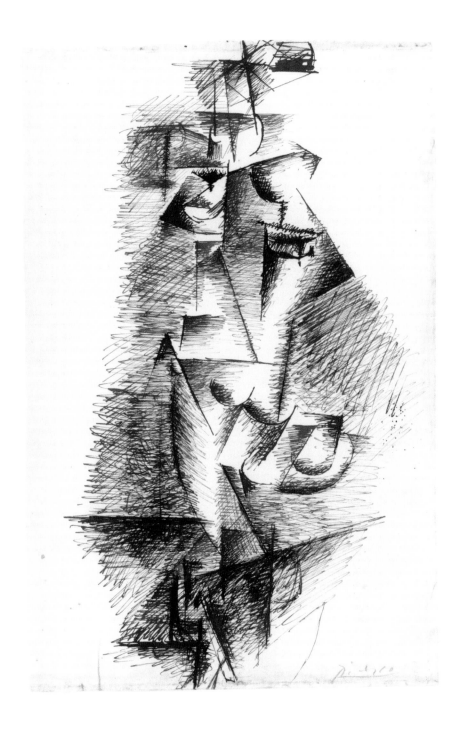

10

Saint Matorel, 1910 (published 1911)

Four etchings, each 20 × 14.1cm plate;
26.5 × 22.6cm sheet
Staatsgalerie Stuttgart, Graphische Sammlung
Inv. GL 1061
Illustrated: *Mlle Léonie*

Picasso and the poet Max Jacob met in 1901 and
became great friends. These four etchings for
Jacob's book *Saint Matorel* were commissioned
by Daniel-Henry Kahnweiler in April 1910.
Kahnweiler had initially asked André Derain
to provide the illustrations, but he declined.
Picasso's work had been used in books before
(one of the *Saltimbanque* etchings was repro-
duced in a book by André Salmon and two
woodcuts appeared in a book by Guillaume
Apollinaire) but this was his first important
book project. Picasso's etchings for *Saint
Matorel* have little to do with Jacob's text, which
is a strange tale about the religious conversion
and subsequent canonisation of its *petit bour-
geois* hero. The etchings have acquired the titles
Mlle Léonie (she is a character in the book), *The
Table*, *Mlle Léonie on a Chaise Longue* and *The
Convent* but these titles were not given by
Picasso. The final etching, seemingly of a reli-
gious building, may refer to the convent of S.
Teresa in Barcelona, where, in the book, Saint
Matorel dies. The four etchings (and a fifth,
which was not used) were begun in July 1910 in
Cadaqués in Spain, and were finished by the
autumn. They were printed by Eugène Delâtre.
The book was published in an edition of one
hundred copies in February 1911. *Saint Matorel*
was the first in a trilogy of books by Jacob.
Derain illustrated the second volume in 1912
and Picasso also illustrated the third, *Le Siège de
Jerusalem* (The Siege of Jerusalem), which was
published in 1914. In 1915, when Jacob became a
Catholic, Picasso acted as his godfather.

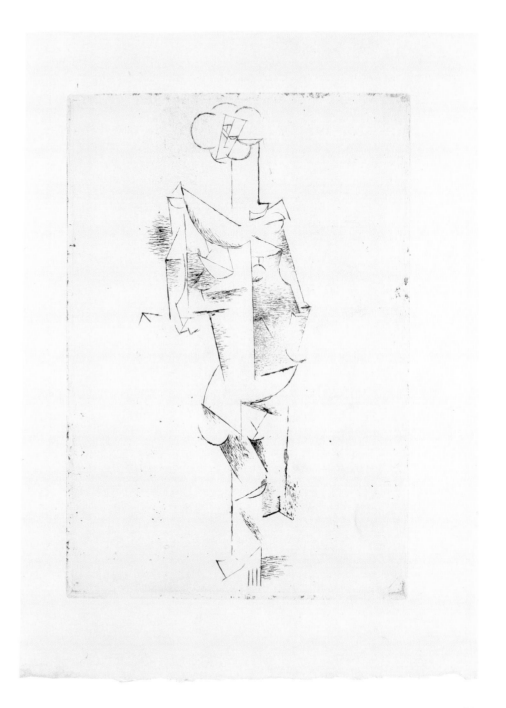

11

Still Life with Bottle of Marc, 1911

[Nature morte à la bouteille de marc]
Drypoint, 50 × 30.6cm plate; 68 × 45.2cm sheet
Staatsgalerie Stuttgart, Graphische Sammlung
Inv. A 69/4825

This still life dates from August 1911, when
Picasso and Braque were staying in Céret, in the
French Pyrenees. As such it is one of Picasso's
earliest works to feature lettering, something
Braque had introduced into his paintings and
etchings several months earlier. Here the letter-
ing signals the label of a bottle of marc – an *eau
de vie* spirit. The lettering 'VIE' is a pun on *eau de
vie* and also stands for 'VIE[UX] MARC', meaning
aged marc. Three playing cards can be made out
in the centre foreground, while a stylised glass
stands to the left. The lettering probably refers to
Picasso's new lover Marcelle Humbert (better
known as Eva): 'VIE MARC' is a cryptogram
meaning 'Life Marcelle'. This reading is empha-
sised by the prominent card bearing the ace of
hearts. Picasso's girlfriend Fernande Olivier was
still on the scene in mid-1911 so Picasso had to
keep the tryst secret from her (Baer 1997, p.32).
Braque made a similar etching at exactly the
same time. Both works were commissioned by
their dealer, Daniel-Henry Kahnweiler, and
printed in editions of one hundred.

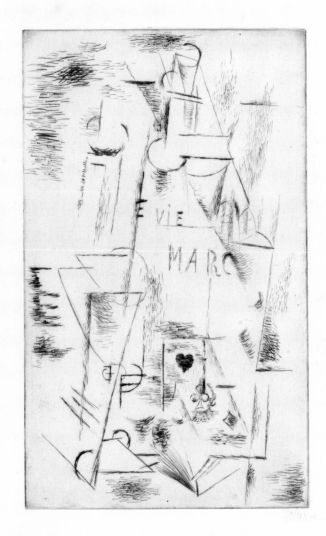

12

Bottle and Glass, 1912

[Bouteille et verre]
Papier collé with pencil, 62.2 × 47.5cm
Staatsgalerie Stuttgart, Graphische Sammlung
Inv. C 80/3047

Georges Braque made the first *papiers collés* (stuck papers) early in September 1912, when he pasted pieces of wood-grained paper onto a drawing. On seeing Braque's new works, Picasso immediately did likewise. Picasso used all kinds of paper, including music scores, advertisements and newspapers. The abbreviated form on the right, with its circular base and rectangular volume, is a glass, while the bottle is signalled by its neck and semi-circular base. The edge of the café table is indicated by the curved form in the lower left. Picasso sometimes selected the newspaper texts with care, to make puns between text and image. Here the text has no obvious relation to the picture: it is a curious article about vendetta killings in Albania, going into some detail about the treatment of bodies prior to burial. Françoise Gilot, who became Picasso's mistress towards the end of the Second World War, recorded Picasso's statement about these collaged works: 'The purpose of the *papier collé* was to give the idea that different textures can enter into compositions to become the reality in the painting that competes with the reality in nature. We tried to get rid of *trompe l'oeil* to find a *trompe l'esprit*. We didn't any longer want to fool the eye; we wanted to fool the mind. The sheet of newspaper was never used in order to make a newspaper. It was used to become a bottle or something like that. It was never used literally but always as an element displaced from its habitual meaning into another meaning to produce a shock between the usual definition' (Gilot 1964, p.72). This *papier collé* probably dates from December 1912.

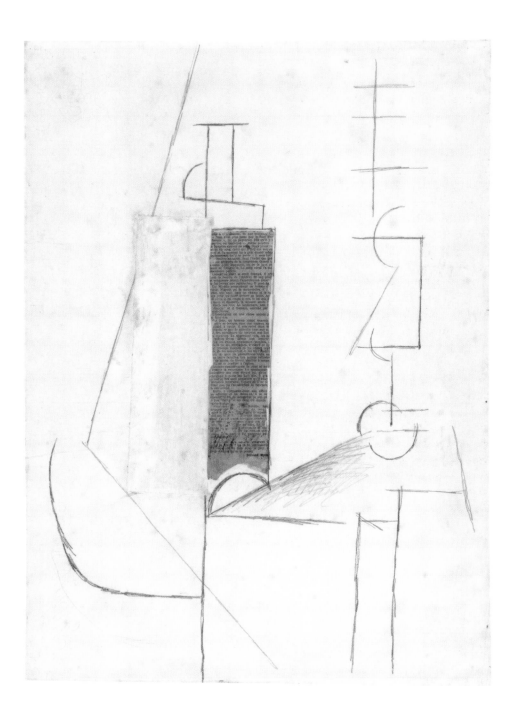

13

Head, 1913

[Tête]
Papier collé with black chalk on card, 43.5 × 33cm
Scottish National Gallery of Modern Art
GMA 3890; purchased with assistance from the
National Heritage Lottery Fund and The Art
Fund, 1995

This work was made in the spring of 1913,
when Picasso was staying in Céret, in the French
Pyrenees. One of Picasso's most abstract and
economical *papiers collés*, it is made up of a few
strips of coloured paper: only the chalk lines
defining the nose and eyes, and the semi-circular
line defining the back of the head are easily
decipherable. Once these signs have been read,
the pasted papers fall into place as face and neck.
Around this date, Picasso used almost the same
shapes to depict musical instruments and still-
lifes. This ability to suggest the metamorphosis
of one form into another was hailed by the
Surrealists as one of Picasso's great achieve-
ments. Although it pre-dates the founding of
Surrealism by more than a decade, *Head* has an
important place in the history of Surrealism. It
belonged to the leader of the surrealist group,
André Breton, who bought it in 1923. He made it
the first illustration in his book *Le Surréalisme et
la peinture*, published in 1928. Breton lent it to
the great exhibition of surrealist art held at the
Burlington Galleries in London in 1936. Roland
Penrose, who co-organised the exhibition, tried
to buy it at the time but Breton refused. Never-
theless, a few months later and in desperate need
of money, Breton changed his mind, but did so
with a heavy heart: 'I am madly keen to keep this
little picture which took me years to track down…
It is also the last Picasso I have, and I fear, that
when I no longer have it I will feel poorer still.'
(SNGMA, Penrose Archive: A35/1/1/RPA703/7,
letter 6 July 1936.)

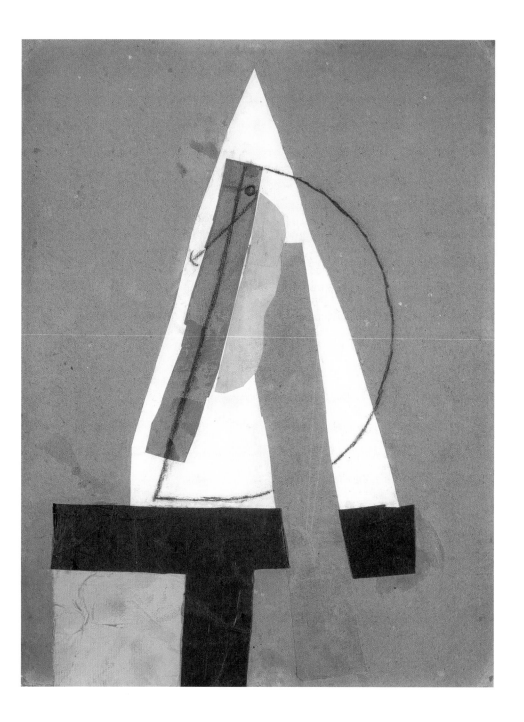

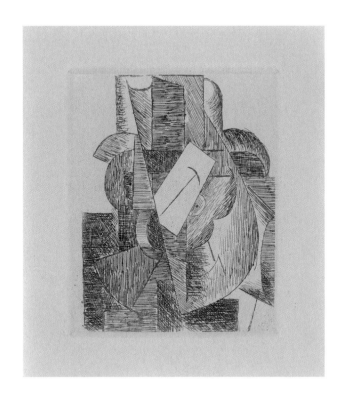

14
Man in Hat, 1914

[L'Homme au chapeau]
Etching, 6.9 × 5.7cm plate; 25.5 × 20.5cm sheet
Private Collection

This etching was made late in 1914 but, like many of
Picasso's cubist etchings, was not printed at the time. In 1947
the artists Albert Gleizes and Jean Metzinger produced a
new edition of their celebrated early book on Cubism, *Du
Cubisme*, which had first been published in 1912. They
planned a de-luxe edition and asked artist friends who had
been involved in the cubist movement to give them original
illustrations. Duchamp, Gleizes, Metzinger, Laurencin,
Picabia, Villon and Picasso all provided etchings. Picasso
must have unearthed this uneditioned plate especially for
them. The book was published in an edition of 470 copies.

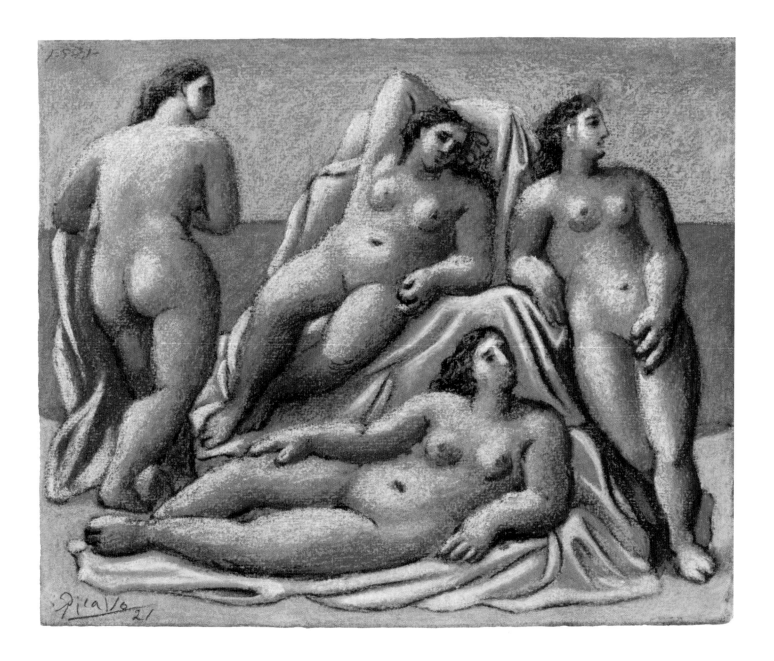

15

Group of Female Nudes, 1 May 1921

[Groupe de nus féminins]
Pastel, 24.3 × 29.9cm
Staatsgalerie Stuttgart, Graphische Sammlung
Inv. C 59/915

In 1914–15 Picasso surprisingly changed tack. Known as the co-inventor and leading light of the cubist movement, he quietly made a number of drawings which are extremely realistic. The reasons for this change are much debated: one is that he may have wanted to distance himself from his growing band of cubist followers. The switch became more apparent a couple of years later, when he fell in love with, and then married, the ballet dancer Olga Khokhlova (1891–1954) and became involved with the Ballets Russes company. It is an often-repeated truism that Picasso's work changed in style whenever a new woman came into his life, and his early years with Olga are characterised by this naturalistic and classical style. A trip to Italy in 1917, when Picasso visited Rome, Naples and Pompeii, also contributed to this change of style. In these years he oscillated between Cubism and Naturalism, sometimes combining both approaches in a single picture. His classical style was much indebted to Renoir's late nudes, indeed Picasso bought a large Renoir painting, *Seated Bather in a Landscape*, in 1919. Picasso's work reached its apogee in terms of big classical figures in 1921. This pastel drawing is one of two very similar works, both of which belong to the Staatsgalerie Stuttgart. This one is dated 1 May 1921 and the other is dated 4 May 1921. Picasso had spent the previous summer at Juan-les-Pins, on the French Riviera, and he subsequently made a number of drawings and paintings of beach scenes, including several with mythological subjects. This pastel was illustrated on the cover of the Ballets Russes's programme for the ballet *Cuadro Flamenco* in May 1921. Picasso also designed the sets but only one performance was ever staged.

16

Interior Scene, 1926

[Scène d'intérieur]
Lithograph, 22.3 × 28cm image;
38.3 × 56cm sheet
Staatsgalerie Stuttgart, Graphische Sammlung
Inv. A 80/5923

Lithography means, literally, stone drawing. Lithographs are made by drawing an image onto a specially prepared lithographic stone, using a greasy pencil. The stone is then washed and when ink is applied it sticks to the drawn areas. Zinc plates can also be used, and the artist can also draw on special paper which can be transferred to the lithographic stone or zinc plate. In the first half of his career, Picasso seldom used lithography: he made about thirty lithographs in the 1920s and none at all in the 1930s. They are not particularly adventurous: most resemble his drawings. This enigmatic work is one of his more imaginative lithographs. It shows two figures locked in a complex web of lines and patterns. Related sketchbook drawings in the Musée Picasso in Paris (MP.1871) clearly show that the figure on the right is holding a child on a bicycle (see Léal 1996 vol.2, p.52–3). This is, then, probably a depiction of Picasso's wife Olga teaching their five-year-old son Paulo how to ride a bicycle. The figure on the left may be Picasso himself, drawing the scene. The image combines Surrealism with what the art historian Alfred Barr called 'Curvilinear Cubism'.

17

Woman, Front and Profile, 1926

[Femme en face et en profil]
Pen and ink with charcoal and gouache,
62 × 47cm
Staatsgalerie Stuttgart, Graphische Sammlung
Inv. c 49/147

This drawing, which is dated 1926, is a characteristic semi-surrealist work of the mid-1920s, incorporating both frontal and profile views in a single image. There is a similar painting in the Musée d'Art Moderne in Strasbourg, and some related sketches dating from about March 1926 are in the Musée Picasso in Paris. Some consider this group of works to be portraits of Picasso's lover, Marie-Thérèse Walter (1909–1977). When questioned, Marie-Thérèse always maintained that she first met Picasso on 8 January 1927, outside the Galeries Lafayette department store in Paris, when she was seventeen years old. That view was subsequently challenged by an amateur art historian, Dr Herbert Schwarz, who noted that a large number of Picasso's paintings, drawings and prints dating from 1925 and 1926 depicted Marie-Thérèse, with her distinctive round face, clear eyes and blond, bobbed hair. He argued that the tryst had been hushed up because Marie-Thérèse would still have been a minor. Schwarz's arguments found support among some leading Picasso scholars (see Rubin 1996, pp.60–3 and 336–83). However, Picasso's biographer, John Richardson, believes that Picasso and Marie-Thérèse did indeed meet in January 1927, and will argue so in the forthcoming third volume of his definitive biography. Furthermore, Diana Widmaier Picasso has recently found convincing evidence for the January 1927 meeting (see Muller 2004, pp.28–9). This drawing would, then, appear to be a portrait of someone who resembled Marie-Thérèse, but was probably a little older. This reading would fit into a pattern, for Picasso made other drawings and paintings of women who looked like his lovers – Françoise Gilot and Jacqueline Roque, for example – before he had even met them. It seems that he was attracted to women who resembled the figures in his paintings.

Marie-Thérèse became Picasso's lover and muse for a decade and she is the dominant theme in his work of the late 1920s and early 1930s. In the early 1930s Picasso gradually edged his wife Olga Khokhlova (whom he had married in 1918), out of his life and art. Remarkably, Marie-Thérèse's existence, and the fact that she and Picasso had a daughter, remained little known until the 1950s.

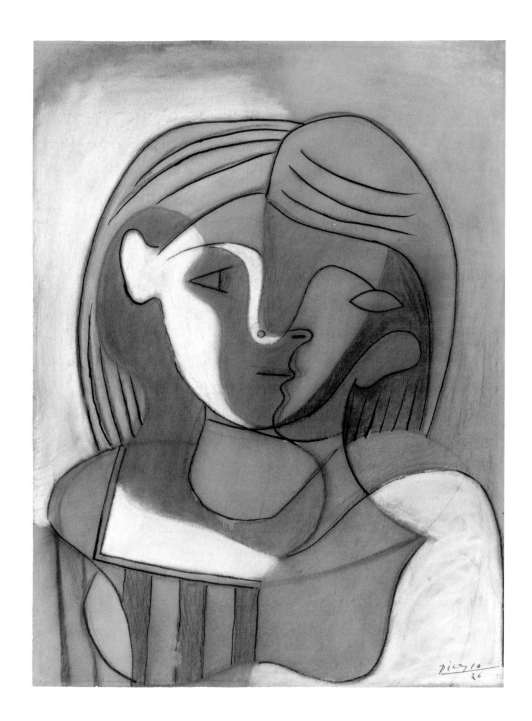

18
Le Chef-d'oeuvre inconnu,
1927–9 and 1931

[The Unknown Masterpiece]
Thirteen etchings, each 19.4 × 27.7cm
or 27.7 × 19.4cm sheet
Staatsgalerie Stuttgart, Graphische Sammlung
Inv. D 61/203
Illustrated: *Painter and Model Knitting* and
Bull and Horse in the Arena

In 1926 Ambroise Vollard commissioned
Picasso to illustrate Honoré de Balzac's *Le Chef-
d'oeuvre inconnu*. The short story, set in the
seventeenth century, tells of a celebrated, elderly
artist called Frenhofer and his years of secret
struggle to create the ultimate masterpiece.
When the young Nicolas Poussin and another
artist finally see the picture, they discover that it
is an incomprehensible mess of colours and lines.
The theme must have appealed greatly to
Picasso. Between 1927 and 1929 he produced
twelve etchings which do not illustrate events in
the story, but instead explore the relationship
between the artist and his model. The etching
Painter and Model Knitting is the closest to
Balzac's story, showing an artist keenly observ-
ing his model and representing her as a tangled
web of lines. The theme of the artist at work and
of artistic creation in general was central to
Picasso's oeuvre, appearing also in the 'Sculp-
tor's Studio' etchings in the *Vollard Suite*
(cats.25–8) and in many of his late works. In
1931 Picasso produced a thirteenth etching
which features thumbnail sketches of the origi-
nal twelve etchings.

The neoclassical style of the works derives
from a variety of sources, including ancient
Greek vases, the incised drawings on the backs of
Roman mirrors and the drawings of Ingres. This
economical, linear style would dominate
Picasso's graphic output during the early 1930s.

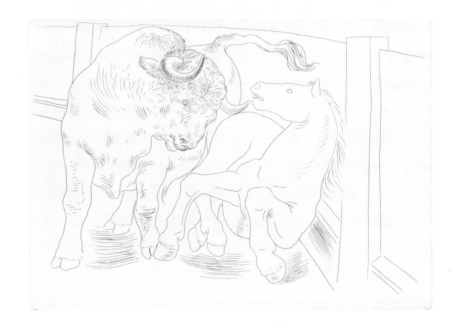

The book also features woodcut reproductions of
the abstract, line-and-dot drawings which Picasso
had made while holidaying in Juan-les-Pins in
1924. The book was produced in an edition of 340
copies. It was published at the end of 1931, at
almost the same time as another book project
undertaken by Picasso, Ovid's *Metamorphoses*,
which had been commissioned by Vollard's great
rival, Albert Skira.

In 1937 Picasso was offered a studio in the
grand seventeenth-century house at 7 rue des
Grands-Augustins, featured in Balzac's novel as
the meeting place between Frenhofer and Poussin.
Picasso's friend the photographer Brassaï recalled
that 'moved and stimulated by the idea of taking
the place of Frenhofer's illustrious shadow, Picasso
rented the atelier at once' (Brassaï 1964, p.58).

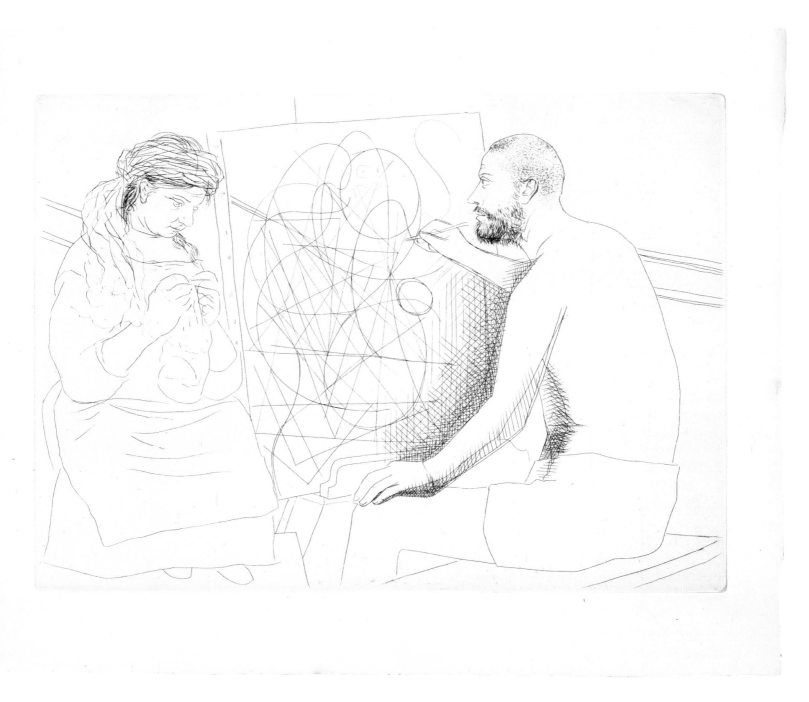

19

**On the Beach: Three Bathers,
23 November 1932**

[Sur la plage: trois baigneuses]
Etching in book, 12.5 × 9.2cm plate;
24.5 × 32.5cm sheet
Scottish National Gallery of Modern Art
A.35/2/RPL1/0046; purchased with assistance
from the National Heritage Memorial Fund and
The Art Fund 1994

This etching dates from November 1932 but it
was not published until July 1935, when it was
included in a book assembled by Anatole
Jakovski, *23 Gravures*. The subject of three
female nudes recurs throughout Picasso's oeuvre:
it is a traditional subject, dating back to Greek
treatments of The Three Graces. This is one of a
major series of paintings and etchings of figures
playing on the beach, done in the second half of
1932. Towards the end of the year, Picasso's lover,
Marie-Thérèse Walter, picked up a life-threaten-
ing virus following a swim, and some of Picasso's
more frenetic bather compositions of this date
seem to refer to this incident. Jakovski's book
featured prints by twenty-two other artists,
including Arp, Giacometti and Miró. Fifty copies
of the book were published; this copy formerly
belonged to Picasso's biographer and friend
Roland Penrose.

20
Bathers with a Balloon II,
2 December 1932

[Baigneuses au ballon II]
Etching with collage in book, 11.4 × 14cm plate;
19.2 × 14.2cm sheet
Scottish National Gallery of Modern Art
A35/2/RPL1/0391; purchased with assistance
from the National Heritage Memorial Fund and
The Art Fund 1994

Picasso's etching appeared as the frontispiece
in just twenty-eight de-luxe copies of Georges
Hugnet's book *Petite anthologie poétique du
surréalisme*, which was published by Editions
Jeanne Bucher in 1934. Picasso kept his distance
from the corporate element of the surrealist
movement, but he must have agreed to contri-
bute this print because Hugnet – a writer, artist
and bibliophile – was a good friend. When asked
to provide frontispieces for friends' books,
Picasso would usually select a pre-existing work,
rather than make a new one: this etching dates
from 1932, while the book was published two
years later. In 1932 Picasso had installed a print-
ing press in his new home at Boisgeloup, north of
Paris. He printed all the impressions of this work
himself, adding collaged elements: this copy
features three cigar labels. Some of the prints
were printed in negative, others in positive, as
here. The lines in this print are so deeply etched
that they have trapped bubbles in the acid-
etching process. Most printmakers would regard
this as a mistake, but Picasso liked to overstep
boundaries.

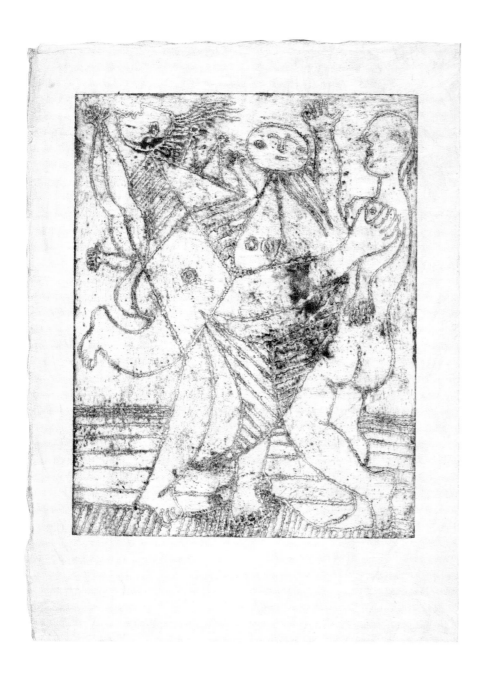

21

The Three Bathers:
The Three Graces, 7 December 1932,
published 1933

[Les Trois baigneuses: Les trois grâces]
Etching with collage in book, 14.1 × 11.3cm plate;
14.3 × 19cm sheet
Scottish National Gallery of Modern Art
A.42.0432; bequeathed by Gabrielle Keiller 1995

This etching was made in December 1932, but
was only published the following year when it
was used as the frontispiece in Tristan Tzara's
book *L'Antitête*. Tzara's text was in three parts,
making the choice of this print, with its three
bathers, appropriate. Picasso printed the etchings
himself. They were included in just eighteen de-
luxe copies of Tzara's book.

22

Bather, 11 April 1933

[Au bain]
Pen and ink, 22.8 × 28.8cm
Staatsgalerie Stuttgart, Graphische Sammlung
Inv. C 64/1288

The subject of this ink drawing seems to be
loosely based on 'Susanna and the Elders', only
here the voyeurs are young boys, not old men as
in the Old Testament story. Voyeurism became a
central theme of Picasso's late work (see cats.62
and 83).

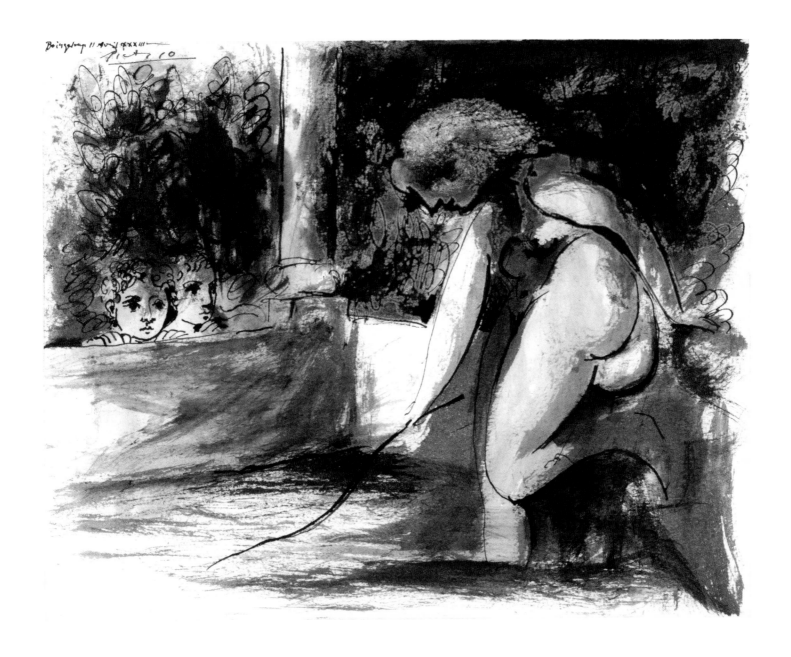

53

23

Woman in an Armchair Dreaming (plate 21 from the Vollard Suite), 9 March 1934

[Femme au fauteuil songeuse]
Etching, 27.8 × 19.8cm plate; 44.5 × 34cm sheet
Collection of Henry and Sula Walton

Picasso met Ambroise Vollard in 1901 and held an exhibition at his gallery in June that year. Vollard showed a particular interest in Picasso's prints: in 1913 he published the fourteen etchings which make up the *Saltimbanque Suite* (cats.2–4) and in 1926 he commissioned Picasso to illustrate Balzac's *Le Chef-d'oeuvre inconnu* (cat.18). The history of the *Vollard Suite*, which comprises one hundred etchings and engravings, is complicated. There is no specific documentation on the background to the project. Some state that it was commissioned around 1927 (Tinterow 2006, p.113) while others place the date in the early 1930s, after Picasso had already made some of the etchings. Others contend that it was never commissioned and that Vollard simply acquired a large number of Picasso's etching plates over a period of several years and that the final selection was more a matter of opportunism than design. The earliest prints in the series date from September 1930 and the last – three portraits of Vollard – were made in 1937. Instead of a fee, Picasso swapped at least some of the plates for paintings by Renoir and Cézanne. It has recently emerged that Vollard commissioned a text from the poet André Suarès to accompany the publication and that this was ready by 1938 (Tinterow 2006, p.114). In 1925–6 Suarès had collaborated with Vollard and Picasso on another project, *Hélène chez Archimède*, which was due to have woodcut illustrations but which was then abandoned. For this new project, Suarès wrote a pair of texts, *Minotaure* and *Minos et Pasiphaé*. However, Vollard died in a car accident in July

1939, at the moment the etchings were being printed, and the idea of a joint publication of text and images died with him. There was an edition of 260 sets of the one hundred prints, plus another fifty sets on larger sheets and another three sets on parchment: this was a huge job involving the printing of more than 30,000 sheets. The printing was finished by Roger Lacourière in 1939 but the suites were not assembled immediately and the outbreak of war meant that they remained in storage for some years. A dealer called Henri Petiet bought most of the prints from Vollard's estate in 1948. To Petiet's annoyance, another dealer bought the portraits of Vollard, and Petiet had to buy them from him at considerable cost to secure the full edition. The prints were not issued in a binding or, it seems, in any particular order.

In 1956, Hans Bollinger published a book on the *Vollard Suite*. He arranged the prints into several different 'chapters'. According to his schema, the first twenty-seven prints act as a kind of introduction; then there are five prints classified as 'The Battle of Love', forty-six on 'The Sculptor's Studio', four on 'Rembrandt', eleven on 'The Minotaur', and four on 'The Blind Minotaur'. The ordering of the prints is not chronological and it seems that these divisions were made by Bollinger, not Vollard or Picasso. Bollinger's divisions have, however, stuck, leading to confusion about the nature of the project. Lisa Florman argues that Picasso's apparently random development of the imagery was deliberate, and that it has its origins in the *Capricci* etching series by Jacques Callot and Goya (Florman 2000, chapter 3). She also argues that the idea of shuffling the prints about, to establish different connections between them, was intentional.

The style of the prints is resolutely classical, and the figures themselves have the appearance

of Greek and Roman gods and goddesses. In this respect, the *Vollard Suite* continues the pattern Picasso had embarked upon in two earlier book projects, *Le Chef-d'oeuvre inconnu* (cat.18) and *Metamorphoses*. The Sculptor's Studio etchings feature a cast of gods and nymphs and are partly autobiographical, reflecting Picasso's renewed interest in making sculpture. While many of the earlier etchings are in the linear, neoclassical style, others incorporate fine cross-hatching, to give the figures a sculptural feel. Some of the later etchings employ more complicated techniques such as aquatint and sugarlift, which Picasso learned from Roger Lacourière, with whom he began working in 1934. It has been suggested that Picasso worked in a fairly traditional style (few of the prints contain more than a hint of Cubism or Surrealism) in deference to Vollard's taste.

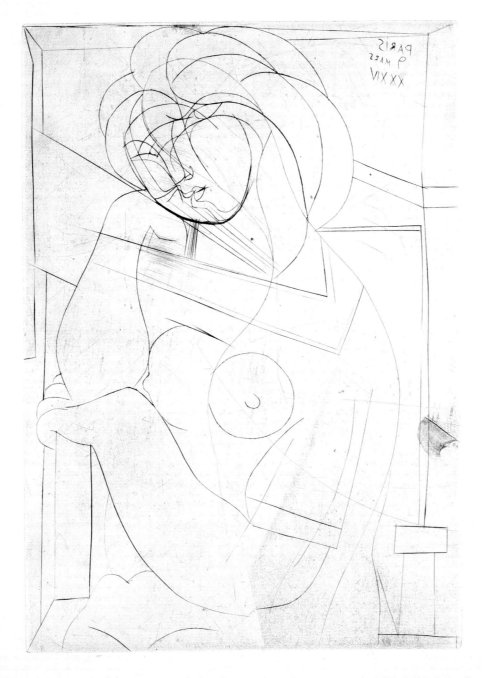

24

Woman with Veil, Seated Model and Head of Rembrandt (plate 35 from the Vollard Suite), 31 January 1934

[Femme au voile, modèle assis et tête de Rembrandt]
Etching, 27.7 × 19.7cm plate; 45 × 33.6cm sheet
Staatsgalerie Stuttgart, Graphische Sammlung
Inv. A 54/1635

Four of the *Vollard Suite* prints include portraits of Rembrandt. Perhaps mischievously, Picasso told his dealer Daniel-Henry Kahnweiler that they had come about by accident: 'It's all on account of that varnish that cracks. It happened to one of my plates. I said to myself, "It's spoiled, I'll just do any old thing on it." I began to scrawl. What came out was Rembrandt. I began to like it and I kept on' (Bollinger 1956, p.xii). The technique employed here is not spitbite, as sometimes said. The grey areas seem to have been produced with a thick etching tool which has not held the ink well.

25
Sculptor and his Self–portrait acting as a Pedestal for a Head of Marie–Thérèse (plate 48 from the Vollard Suite), 26 March 1933

[Sculpteur et son autoportrait sculpté servant de socle à une tête de Marie-Thérèse]
Etching on parchment, 25.2 × 19cm plate;
44.5 × 36cm sheet
Staatsgalerie Stuttgart, Graphische Sammlung
Inv. A 81/5928

Forty-six of the prints which make up the *Vollard Suite* are devoted to the theme of the Sculptor's Studio. Forty of them were completed between March and May 1933, and the remaining six were done in the first months of 1934. In 1930 Picasso had bought a seventeenth-century château at Boisgeloup, north of Paris, and, having converted an outbuilding into a sculpture studio, he soon began an intense period of sculptural activity. In particular, he made numerous busts of his mistress Marie-Thérèse Walter: variants of some of these can be seen in the contemporaneous *Vollard Suite* prints. According to Françoise Gilot, Picasso thought of the sculptor as a kind of God, inventing forms at will and trying out different styles. She recalled his comment: 'God is really another artist. He invented the giraffe, the elephant and the cat. He had no real style. He just keeps on trying other things. The same with the sculptor' (Gilot 1964, p.43). This particular copy of the print comes from one of the three de-luxe editions of the *Vollard Suite* printed on parchment.

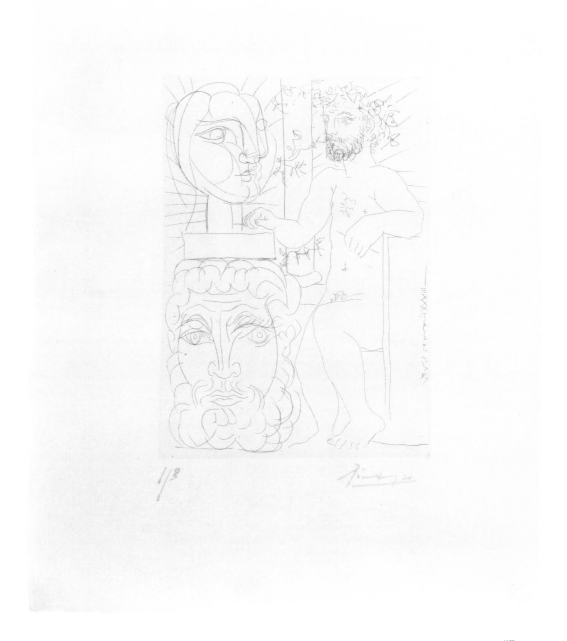

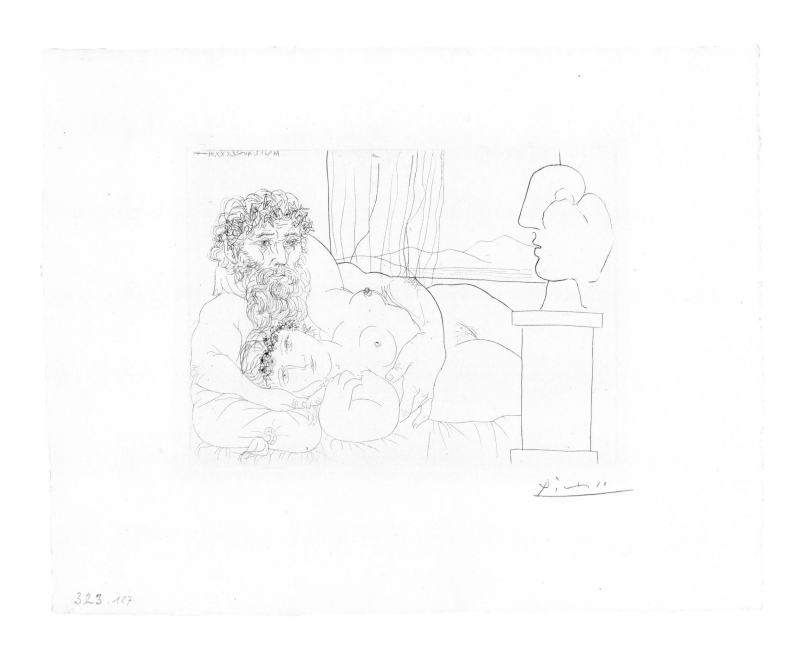

26

**Sculptor and his Model with Sculpted
Head of the Model (plate 62 from the
Vollard Suite), 2 April 1933**

[Sculpteur et son modèle avec la tête sculptée du
modèle]
Etching, 19.3 × 26.8cm plate; 34 × 44.4cm sheet
Staatsgalerie Stuttgart, Graphische Sammlung
Inv. c 54/1633

27

**Sculptor and Model Looking at
Herself in a Mirror Leaning Against a
Self-portrait Bust (plate 69 from the
Vollard Suite), 4 April 1933**

[Sculpteur et modèle se regardant dans un miroir
calé sur un autoportrait sculpté]
Etching, 37 × 29.7cm plate; 44.4 × 33.6cm sheet
Staatsgalerie Stuttgart, Graphische Sammlung
Inv. A 54/1632

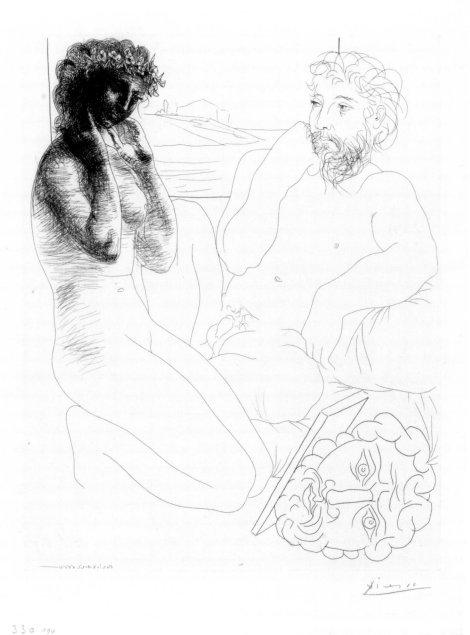

28

Four Female Nudes and Sculpted Head (plate 82 from the Vollard Suite), 10 March 1934

[Quatre Femmes Nues et Tête Sculptée]
Etching and engraving, 22.1 × 31.4cm plate;
34 × 45cm sheet
Scottish National Gallery of Modern Art
GMA 775; purchased 1961

Early states of this print show a different scene, with a nude reclining on a long bed in the foreground, and three female figures sitting or reclining behind her. Picasso subsequently made some major alterations. He added legs to the figure on the left (curiously, her top half is still in the background, while her legs are in the foreground and now cradle the reclining nude) and completely reworked the face of the figure on the right. Brigitte Baer's catalogue raisonné of Picasso's prints subtitles the print 'clin d'œil au Bain Turc', meaning that it makes reference to Ingres's celebrated painting of a Turkish Bath, but any similarity is probably coincidental (Baer 1992, vol.II, cat.424).

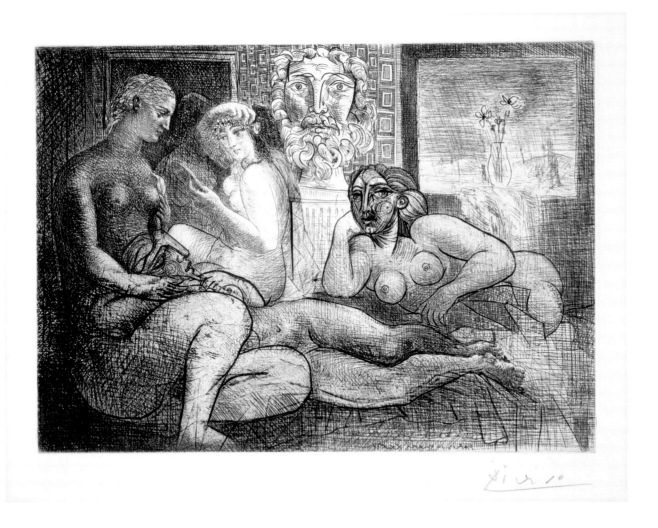

29

Amorous Minotaur with Female Centaur (plate 87 from the Vollard Suite), 23 May 1933

[Minotaure amoureux d'une femme-centaure]
Etching, 19.4 × 26.8cm plate; 33.4 × 44.2cm sheet
Staatsgalerie Stuttgart, Graphische Sammlung
Inv. A 56/1868

Eleven of the prints in the *Vollard Suite* deal with the theme of the Minotaur and another four focus on the Blind Minotaur. Those dealing with the Minotaur were made in May and June 1933 and those dealing with the Blind Minotaur in late 1934 and early 1935. Picasso had treated the Minotaur theme on a number of occasions in the past, but began to look at it afresh after making the cover design for the first issue of the art journal *Minotaure* in April 1933 (it was published in June). His interest in the legend of the Minotaur may have been inspired by the excavations carried out at Knossos, Crete, by the archaeologist Arthur Evans between 1900 and 1931. The legend of the Minotaur, kept by King Minos in a deep labyrinth and fed on human offerings, became popular in the 1920s, when Evans published his findings. Picasso identified with this mythical beast: the Minotaur represented sexual potency and he was also an emblematic 'outsider' figure, like the harlequins and circus performers Picasso had painted during his Rose Period. In his book on the *Vollard Suite*, Hans Bollinger titled this work *Minotaur Assaulting a Girl*, but she is clearly a centaur, with her hind legs appearing in the top left corner. In this sense she is a combination of the female bullfighter and the horse, who regularly feature as separate entities in other Picasso works. Here the Minotaur (and thus Picasso) seems to be having his revenge on both at once. This etching is inscribed with the date 23 May 1933. In her catalogue raisonné of Picasso's etchings, Brigitte Baer notes that while that may be the correct date of the first state, this reworked state shows a more sophisticated etching technique, and must therefore date from late 1934, when Picasso was working with the master printer Roger Lacourière (Baer 1986–96, vol.II, p.190).

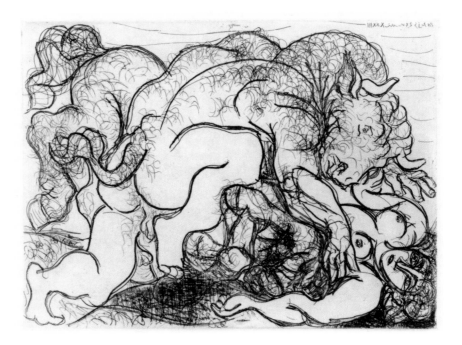

30

Minotaur Caressing the Hand of a Sleeping Woman with his Head (plate 93 from the Vollard Suite), 18 June 1933

[Minotaure caressant du mufle la main d'une dormeuse]
Drypoint, 29.7 × 36.6cm plate;
33.8 × 44.9cm sheet
Staatsgalerie Stuttgart, Graphische Sammlung
Inv. A 54/1636

Picasso discussed this print with his lover Françoise Gilot, saying: 'He's studying her, trying to read her thoughts, trying to decide if she loves him *because* he's a monster. Women are odd enough for that … It's hard to say whether he wants to wake her or kill her' (Gilot 1964, p.43).

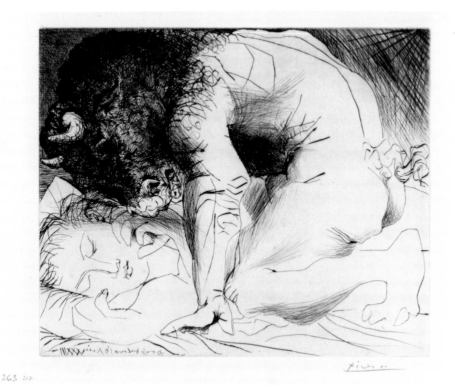

31

Blind Minotaur Guided in the Night by a Young Girl with a Pigeon (plate 96 from the Vollard Suite), 23 October 1934

[Minotaure aveugle guidé dans la nuit par une petite fille au pigeon]
Etching, 23.8 × 29.8cm plate; 33.6 × 44.4cm sheet
Staatsgalerie Stuttgart, Graphische Sammlung
Inv. A 54/1634

The girl who is guiding the blind Minotaur has the face of the artist's lover, Marie-Thérèse Walter. On 23 October 1934, when this print was made, Marie-Thérèse would have been twenty-four and Picasso would have been just two days short of his fifty-fourth birthday. The contrast between the young girl and the ageing Minotaur (Picasso's alter ego), who carries a stick, probably refers to this gap in their ages. Picasso made several variants of this print, culminating in a much larger and more complex variant, *Minotauromachie* (cat.36). The theme of blindness occurred frequently in Picasso's early work (see cat.2). Here the Minotaur's blindness may refer to the legend of the Minotaur's labyrinth on Crete and Ariadne's successful efforts to save her lover Theseus from the maze by guiding him out with a ball of string.

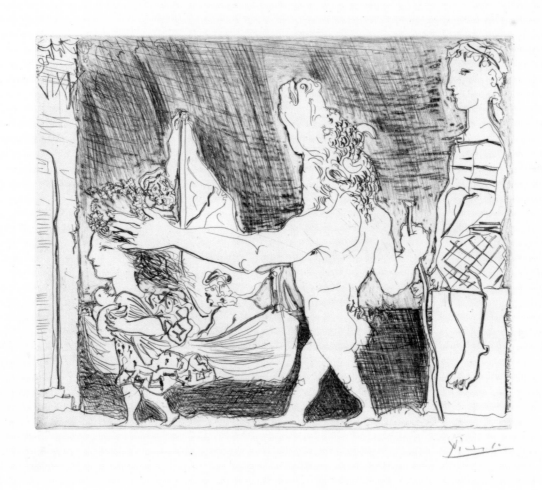

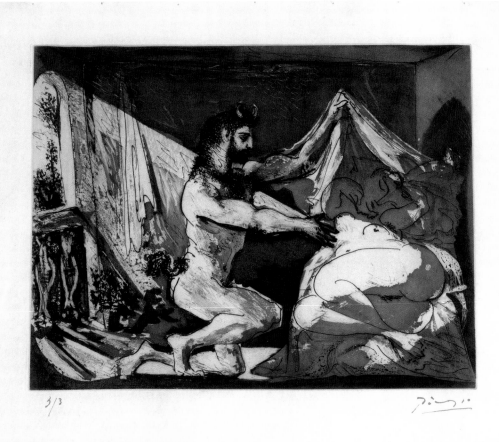

3/3

32

**Faun Unveiling a Sleeping Woman
(plate 27 from the Vollard Suite),
12 June 1936**

[Faune dévoilant une dormeuse]
Aquatint, sugarlift and etching on parchment,
31.3 × 41.1cm plate; 41.4 × 53.7cm sheet
Staatsgalerie Stuttgart, Graphische Sammlung
Inv. A 54/1535

This tender depiction of a faun or a satyr unveiling a sleeping
female nude dates from June 1936, making it one of the last
etchings from the *Vollard Suite*. It is one of Picasso's earliest
sugarlift etchings, a technique he learned from the printer Roger
Lacourière towards the end of 1934. Sugarlift involves painting
the image onto the etching plate with water-based Indian ink
mixed with sugar, and cleaning the plate with warm water to
dissolve the sugar and expose the metal plate. It gives a painterly
effect, as opposed to the linear effect of normal etching.

33
Portrait of Vollard II
(plate 98 from the Vollard Suite), 1937

[Portrait de Vollard II]
Aquatint, 34.8 × 24.7cm plate; 44 × 33.8cm sheet
Staatsgalerie Stuttgart, Graphische Sammlung
Inv. A 54/1527

Ambroise Vollard (1866–1939) was born on the
Reunion Islands. Moving to France in 1885, he
initially studied law but then devoted his atten-
tions to art. He began dealing privately around
1890 and established a gallery in Paris in 1893.
He was one of the leading dealers in the work of
Gauguin, Cézanne and Van Gogh. He staged
Picasso's first exhibition in Paris, in 1901, and
held another in December 1910. This is one of the
three portraits of Vollard included in the *Vollard
Suite*, bringing the total number of prints up to
one hundred (there was also a fourth, which was
not selected). Picasso had first portrayed the
notoriously vain dealer in a cubist painting of
1910, and again in a very realistic pencil drawing
of 1915. There is also a portrait of 1901 which
some believe to be of Vollard. Vollard's entertain-
ing but unreliable autobiography, *Recollections
of a Picture Dealer*, was published in 1937, the
year this print was made.

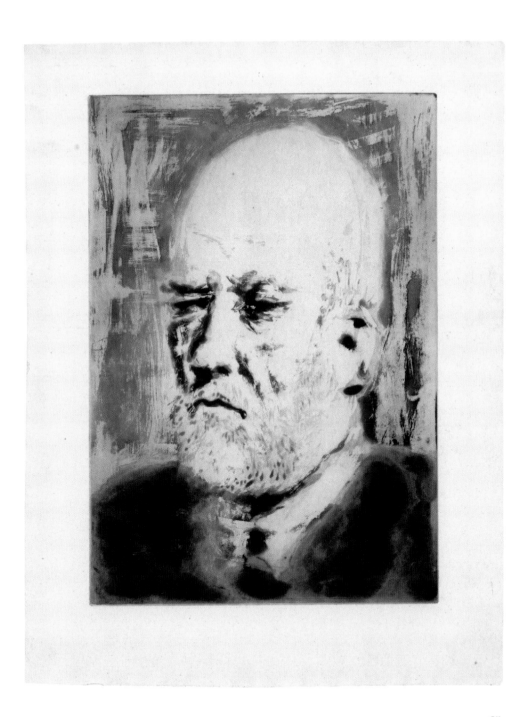

34

The Death of Marat, 21 July 1934

[La Mort de Marat]
Drypoint and coloured ink, 13.5 × 10.6cm plate;
20.3 × 15.1cm sheet
Scottish National Gallery of Modern Art
GMA 4075; bequeathed by Gabrielle Keiller 1995

This was published as a loose frontispiece in Benjamin Péret's book *De derrière les fagots*, which was issued by Editions Surréalistes in 1934. The subject comes from Jacques-Louis David's celebrated neoclassical painting *The Death of Marat*. Picasso made a painting on this theme in 1931 and a similar drawing on 7 July 1934 (Musée Picasso, Paris, MP.1135). The theme may relate to Picasso's complicated love life, with the dying figure standing for Marie-Thérèse Walter, while the screaming killer, wielding a hefty knife, could be Picasso's wife Olga. The violent subject matter has a close parallel with slightly earlier works by the surrealist artist André Masson. The drypoint was executed in July 1934 and the book was printed in August. The smudged, coloured patches were probably added by a monotype technique. This would have been done by wiping the inked copper plate with gouache or coloured ink, and then printing it. In this way, the colouring on each print would have been unique. Fifty copies of the print were produced on different papers, but only a few had the coloured additions.

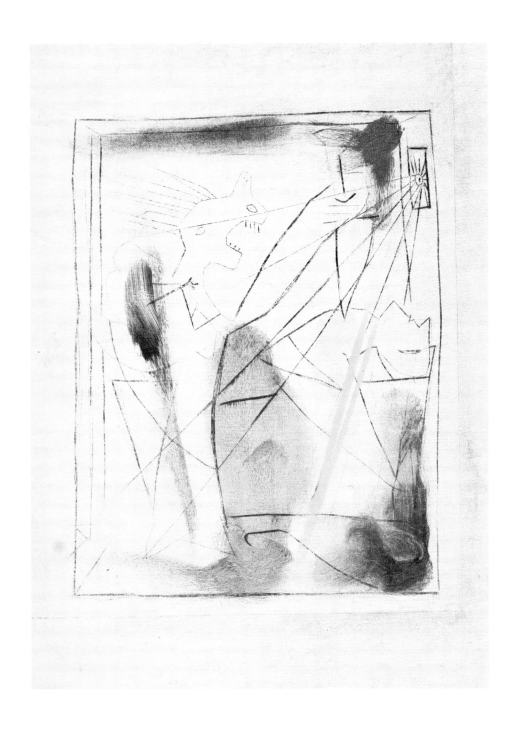

35

Large Corrida, with Female Bullfighter, 8 September 1934

[La Grande corrida, avec femme torero]
Etching, 49.4 × 69cm plate; 56.8 × 77cm sheet
Scottish National Gallery of Modern Art
GMA 2287; purchased 1981

During 1934 Picasso made numerous portrayals of the Minotaur, but towards the end of the year his interest turned to the theme of the bullfight. This subject had appealed to him since childhood: he had painted a bullfight scene when he was just eight years old. Goya's famous etchings of bullfights must also have inspired him. Picasso's renewed interest in the bullfight coincided with a trip to Spain in August 1934, when he saw a number of bullfights in different cities. As has often been pointed out, Picasso was particularly interested in the relationship between the bull and the horse, which he refigured as a metaphorical battle between the male and the female. In his own private mythology, the bull and the horse, the painter and the model, the man and the woman, were locked together in struggle. Here the female *rejoneadora* (a *matadora* who fights from a horse, using a lance) is being carried off by the bull. Spanish law forbade female bullfighters to fight on foot, but allowed them to fight from horseback. Picasso's interest in the theme of the bullfight and violence has been associated with his tempestuous private life. By 1934 he was preoccupied with his mistress Marie-Thérèse Walter, and his relationship with his wife Olga was in terminal decline. Marie-Thérèse gave birth to a daughter in 1935. Here, the woman in the top right corner is Marie-Thérèse. This etching was not editioned until 1939 and Picasso kept all fifty copies. It only became available for sale after Picasso's death in 1973. Picasso made a painting of the same subject on 9 September, the day after making this etching.

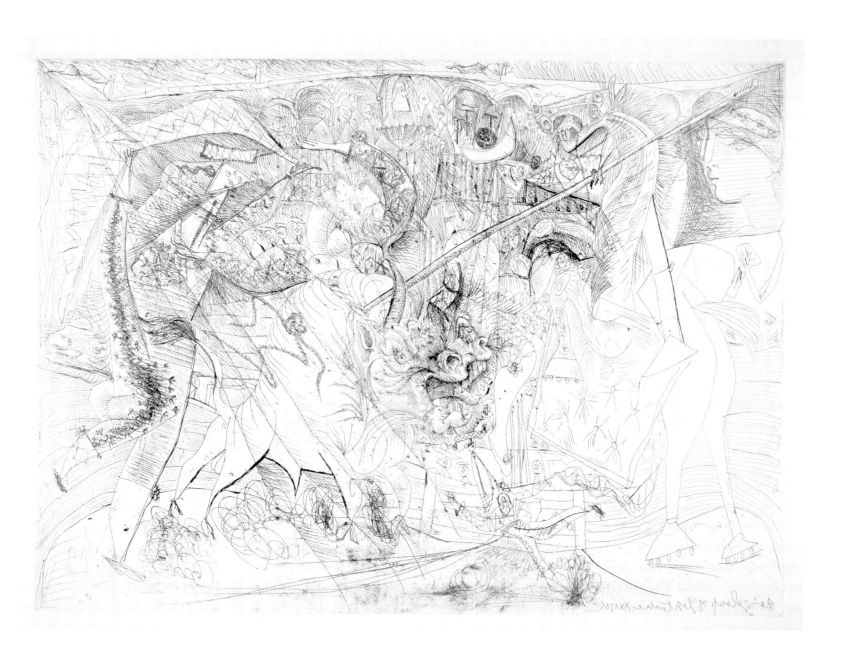

36

Minotauromachie, 23 March 1935

[La Minotauromachie]
Etching, engraving and grattoir, 49.5 × 68.7cm
plate; 57.3 × 77.2cm sheet
The Syndics of the Fitzwilliam Museum,
Cambridge
Inv. P.11–1936; given by Helen M. Inman, 1936

Minotauromachie has long been recognised as Picasso's greatest print. It develops from a series of etchings included in the *Vollard Suite* which show a blind Minotaur being led by a young girl (cat.31). Its unusual iconography has given rise to many different interpretations, some of them convoluted. What is generally agreed upon is that the Minotaur is Picasso's alter ego and that the four female figures – the *matadora*, the girl with the candle and the two figures watching from a tower – are all based on his lover Marie-Thérèse Walter. The horse has been badly wounded, presumably by the Minotaur, and its innards spill out from the hole in its stomach. The iconography seems, then, to be autobiographical in nature, but its exact meaning is elusive. Brigitte Baer is one of several scholars who have argued that the female bullfighter appears pregnant, and links this with the fact that Marie-Thérèse fell pregnant in November 1934 (Baer 1983, pp.94–6). In other words, the bullfighter and the horse have both been penetrated by the Minotaur. Baer argues that the intestines spilling from the gaping, vaginal hole in the horse's body, are in fact the bullfighter's baby, and that the Minotaur intends to take it away in the bag he carries over his shoulder. (Others argue that the Minotaur is carrying a bullfighter's red cape.) Goeppert notes that it is the girl's candle which illuminates the woman's pregnant state, and that the Minotaur – who is responsible for the pregnancy – seems to be in denial and tries to shield the light from illuminating the truth (Goeppert 1987, p.103). If these interpretations are to be believed, this mysterious and haunting print therefore tells of love, fear, denial, desire and shame. However, Picasso often worked without really knowing what his pictures meant, and he invariably rejected detailed interpretations of his work. Moreover, several of Picasso's bullfighting prints which pre-date Marie-Thérèse's pregnancy do in fact show a very similar female figure being carried off by the Minotaur.

Minotauromachie was etched on Saturday, 23 March 1935, at Roger Lacourière's printing studio. It is the only etching Picasso made that year; indeed Picasso made very little work of any kind that year, devoting himself instead to writing. With Marie-Thérèse pregnant and his wife Olga refusing a divorce, he later described this period as 'the worst time of my life'. The plate size of *Minotauromachie* is the same as *Large Corrida, with Female Bullfighter* (cat.35). It went through seven states: this, the final, seventh state, was printed in an edition of fifty in the autumn of 1935. Helen Inman, a private English collector, was so struck when she saw it that she determined that it must belong to a museum, and promptly bought it and gave it to the Fitzwilliam Museum in Cambridge in 1936. It is probably the first copy of *Minotauromachie* to enter a museum collection.

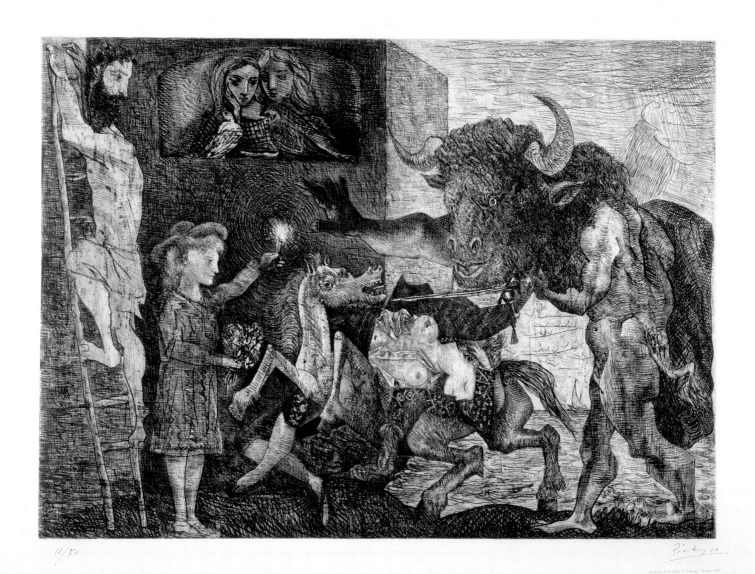

11/50 Picasso

37

The Flea, 1936

[La Puce]
Aquatint and drypoint, 36.6 × 26.9cm sheet
Staatsgalerie Stuttgart, Graphische Sammlung
Inv. A 66/4462

This is one of the prints Picasso made for a new edition of the Comte de Buffon's great bestiary, *Histoire Naturelle*, which was originally published in forty-four volumes between 1749 and 1804. Picasso's version, which was commissioned by Ambroise Vollard, features thirty-one prints of animals, birds and insects. The project began in February 1936 (thus overlapping with the *Vollard Suite*), but was interrupted by Vollard's death in 1939 and the outbreak of the Second World War. It was finally completed in 1942. Picasso made this print of a flea – or rather of a woman, picking off an invisible flee from her behind – even though Buffon had never described the insect in his text. Consequently, it does not feature in the book version but it was issued as an additional, thirty-second print in the loose-leaf edition. In French, 'puce' is a flea while 'pucelle' is slang for a young virgin. Here, Picasso suggestively combines both subjects. The woman is clearly Marie-Thérèse Walter. The pose is based on the celebrated Hellenistic statue of the *Callipygian Venus*.

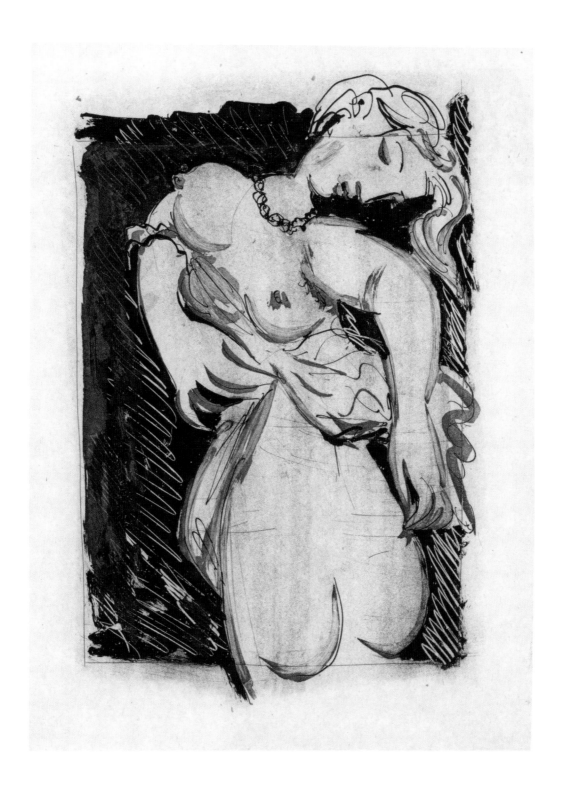

38

**[a] Dream and Lies of Franco (plate I),
8 January 1937**

[Sueño y mentira de Franco (planche I)]
Etching and sugarlift aquatint, 31.7 × 42.2cm
plate; 38.5 × 56.6cm sheet
Staatsgalerie Stuttgart, Graphische Sammlung
Inv. A 51/963

**[b] Dream and Lies of Franco (plate II),
8–9 January and 7 June 1937**

[Sueño y mentira de Franco (planche II)]
Etching and sugarlift aquatint, 31.8 × 42.2cm
plate; 39 × 56.6cm sheet
Staatsgalerie Stuttgart, Graphische Sammlung
Inv. A 51/964

This pair of prints lampoons General Franco, who
in 1936 had led a right-wing military coup which
overthrew Spain's elected left-wing government.
In September Franco was appointed Chief of State
and civil war ensued. This was a matter of deep
significance to Picasso, who never renounced his
Spanish nationality, even though he spent almost

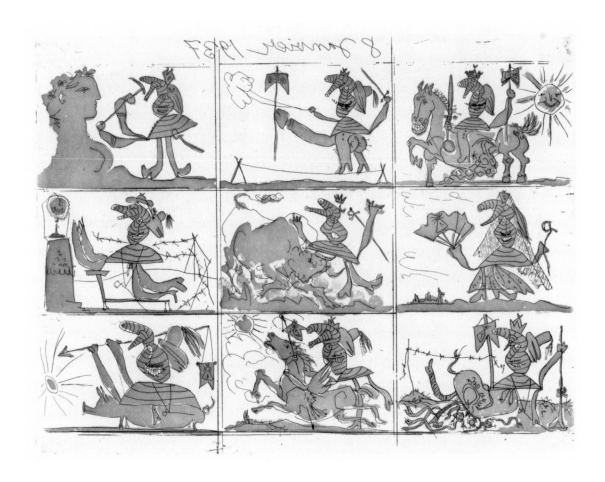

his entire working life in France. The two prints are each divided into nine separate images, each the size of a postcard. In the first fourteen images, dated 8–9 January 1937, Franco is shown as a kind of phallic vegetable, wreaking havoc wherever he goes. Only the bull, which symbolises Republican Spain and perhaps Picasso himself, stands up to him. Following the bombing of Guernica on 26 April, Picasso added four very different images in the second print: these show a weeping woman and scenes of death and destruction. The two prints were issued together with a facsimile of a manuscript by Picasso, all contained in a cover designed by Picasso. The prints were sold at the Spanish Pavilion of the 1937 *Exposition Internationale*, held in Paris: the proceeds went to help Republican causes. The original idea had been to cut out each of the individual images and use them as postcards, but this did not happen. Both prints were issued in editions of 850 copies, with stamped signatures. Unstamped prints were also produced.

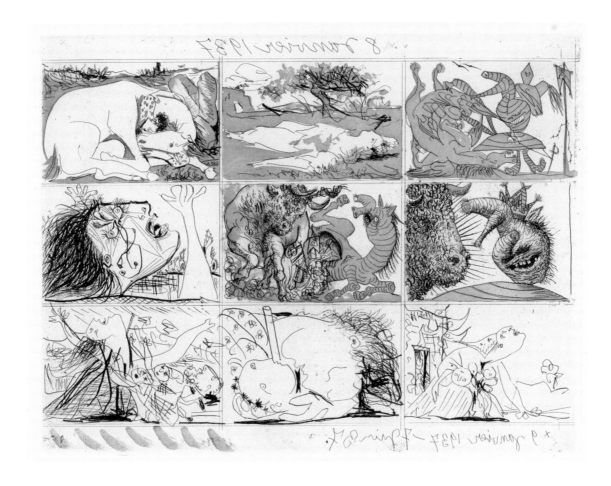

39

Weeping Woman I, 1 July 1937

[La Femme qui pleure I]
Etching, aquatint, drypoint and scraper,
69.2 × 49.5cm plate; 77.2 × 56.9cm sheet
Scottish National Gallery of Modern Art
GMA 4774; accepted by HM Government in lieu
of inheritance tax on the estate of Joanna Drew
2005

In January 1937 Picasso was commissioned to paint a mural for the Spanish Pavilion at the *Exposition Internationale* in Paris. On 26 April 1937, at General Franco's request, the Luftwaffe bombed the Basque town of Guernica. Some 1700 people were killed or wounded. This tragic event gave Picasso his subject. He made a number of drawings and paintings of a weeping woman, although the figure did not eventually appear in the finished work. The drawings did, however, serve as the basis for this great etching, which was made on 1 July. There are seven states: this is the seventh and final state. Only the third and seventh states were editioned for sale. The woman's face is based on Dora Maar, Picasso's mistress at the time: she was a regular visitor to his studio, taking photographs of the development of the *Guernica* mural. An emotional woman, Picasso once said that she was 'always weeping'. As has often been noted, the image of the weeping woman was common in Spanish art, in portrayals of the Virgin as the 'Mater Dolorosa'. Only fifteen copies of the seventh and final state of the print were made: this copy is numbered 5/15. They were printed by Roger Lacourière, who helped Picasso develop his etching technique by teaching him how to use drypoint, aquatint and other more specialist techniques. Roland Penrose, Picasso's biographer, bought two copies of the print directly from the artist in 1937 or 1938. He also bought a similar oil-painting which was subsequently purchased by the Tate Gallery. Penrose gave this copy of the etching to his friend Joanna Drew in or around 1970. Drew worked for the Arts Council and had helped Penrose with the organisation of two Picasso exhibitions. She generously bequeathed the print to the Scottish National Gallery of Modern Art, where it joined many other works which had formerly belonged to Penrose.

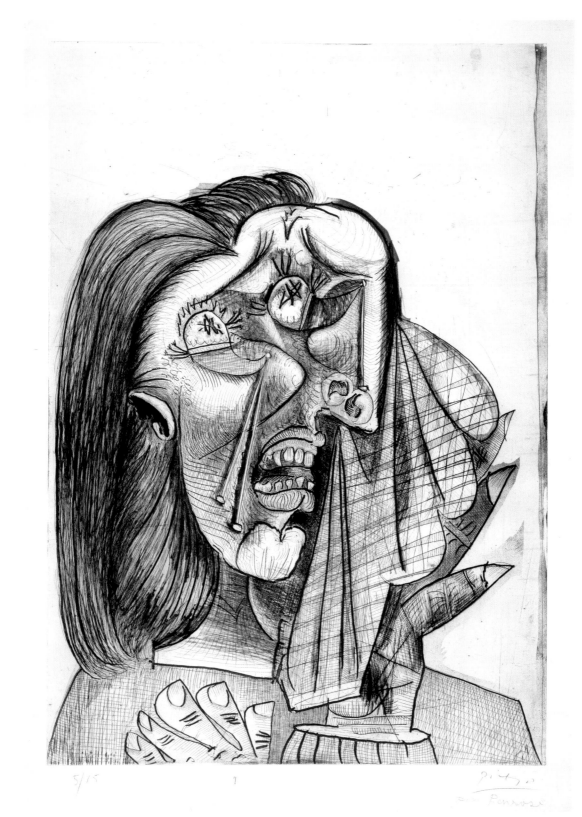

5/15 1 Picasso
 Penrose

40

The Death of a Monster,
6 December 1937

[La Fin d'un monstre]
Pencil, 38.6 × 56.3cm
Scottish National Gallery of Modern Art
GMA 3891; purchased with assistance from the
National Heritage Lottery Fund and The Art
Fund 1995

Dated 6 December 1937, this drawing was immediately acquired by Picasso's great friend, the surrealist poet Paul Eluard. Eluard gave it the title *The Death of a Monster* and wrote a poem inspired by it: *You have to see yourself die / To know you are still alive / The tide is high and your heart is very low / Son of the earth flower-eater fruit of ashes / In your bosom the darkness covers forever the sky.*

In his art, Picasso identified with the Minotaur, seeing him as an outsider figure who had magical powers over women. From April 1933, when he was asked to provide the cover for the new surrealist periodical called *Minotaure*, he returned repeatedly to the subject, particularly in the *Vollard Suite* prints (cats.29–31). Picasso's identification with the half-man, half-monster figure is ambiguous. Françoise Gilot recalled looking through some of the *Vollard Suite* prints with Picasso: 'He turned to another print, a Minotaur watching over a sleeping woman. "He's studying her, trying to read her thoughts," he said, "trying to decide whether she loves him *because* he's a monster"' (Gilot 1964, p.43). It is as if, by the 1930s, Picasso's fame had turned him into a kind of monster. Roland Penrose, who bought this drawing from Eluard in 1938, observed that *The Death of a Monster* was Picasso's last treatment on the theme of the Minotaur (Penrose and Golding 1973, p.114). Picasso did in fact return to the theme on a few occasions in later years (see cats.74 and 91) but this was probably the last time he drew the Minotaur during the 1930s. The woman is based on Marie-Thérèse Walter. By 1937 their relationship was on the wane, though they remained on friendly terms.

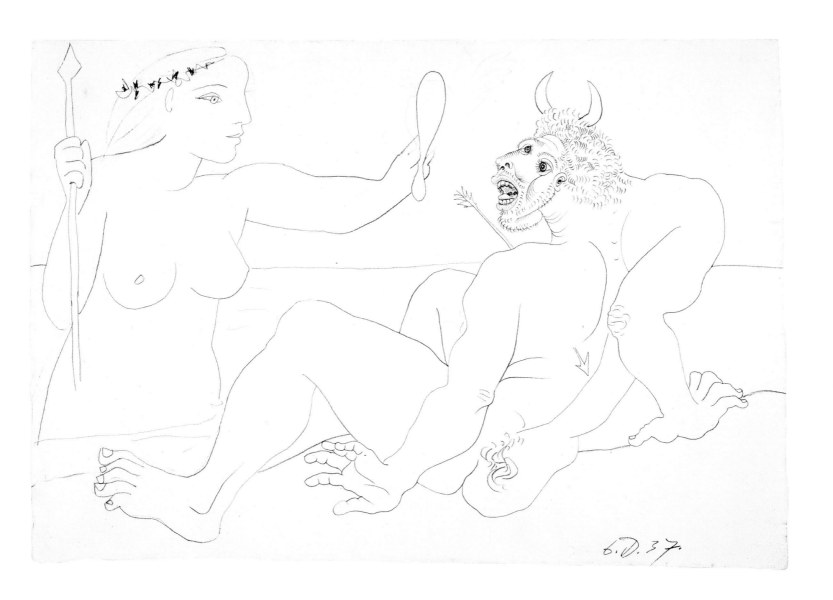

41

Head of a Woman Wearing a Beret, in Profile, 1938

[Tête de femme au béret, de profil]
Engraving in book, 10.4 × 7.5cm plate;
22.6 × 15.9cm sheet
Scottish National Gallery of Modern Art
A35/2/RPL1/0290; purchased with assistance
from the National Heritage Memorial Fund and
The Art Fund 1994

This small portrait of Dora Maar (see cat.43)
was included in a loose-leaf booklet entitled
Solidarité, which was published in Paris in April
1938. It featured a poem by Paul Eluard and
etchings and engravings by six other artists
including Miró, Tanguy and Masson. The booklet
was printed at Stanley William Hayter's Atelier
17 print studio, in an edition of 150: copies were
sold to raise funds for the Spanish Republican
cause. It was Eluard who had introduced Picasso
to Dora Maar in 1936.

42
Head, 1940

[Tête]
Pen and ink, 21.5 × 16.7cm
Staatsgalerie Stuttgart, Graphische Sammlung
Inv. c 65/1407

Made in the town of Royan, on the Atlantic coast
in May 1940, this drawing may be based on Dora
Maar. During the first year of the Second World
War, Picasso and Maar lived semi-permanently
in Royan.

43
Portrait of Dora Maar, 1941

[Portrait de Dora Maar]
Pencil, 31.2 × 23.8cm
Staatsgalerie Stuttgart, Graphische Sammlung
Inv. c 56/664

Henriette Theodora Markovitch (1907–1997), better known as Dora Maar, was the daughter of a Croatian architect. Born in Paris, she grew up in Buenos Aires and thus spoke Spanish. The family moved back to Paris in 1926. By the early 1930s she was working as a professional photographer. She became friendly with a number of writers and artists associated with the surrealist group, including Georges Bataille (her lover), Paul Eluard, André Breton and Man Ray, and her work was often surrealist in spirit. Eluard introduced her to Picasso early in 1936, at the Deux Magots café. She soon became Picasso's lover, usurping Marie-Thérèse Walter, whom Picasso neverthe-less continued to see. Compared to Marie-Thérèse, with her soft, round features and blond hair, Dora Maar had dark, diamond-shaped eyes, a heavy jaw and dark hair. Maar began appearing in Picasso's work almost immediately. She was the inspiration behind *Weeping Woman I* (cat.39) and many of the studies for *Guernica*. In May 1943 Picasso met Françoise Gilot, who in turn supplanted Maar in Picasso's affections. Maar then led a reclusive life in Ménerbes, a village in the Vaucluse in south-eastern France. She was a celebrated photographer and painter, holding numerous exhibitions.

44

Portrait, 21 April 1942

Engraving in book, 13.9 × 9cm plate;
20.8 × 14cm sheet
Scottish National Gallery of Modern Art
A.42.0020; bequeathed by Gabrielle Keiller 1995

In her catalogue raisonné of Picasso's engraved
work Brigitte Baer lists this as *'Portrait of Paul
Eluard(?)'*, but it is probably a portrait of Dora
Maar, as a comparison with cat.43 indicates (Baer
1986–96 vol.III, cat.681). It is an engraving rather
than an etching, and the engraving tool, which
has to be pushed into the metal plate, encourages
the artist to make straight lines rather than
curved ones. It is perhaps for this reason that the
face looks like Dora Maar's but has a slightly
square, masculine appearance. Additionally,
Paul Eluard had short hair (for other portraits
of Eluard by Picasso, see Rubin 1996, pp.78–9).
The print was included in the first twenty copies
of Eluard's book *Au Rendez-vous allemande*, a
collection of poems in which Eluard expressed his
hatred of the German Occupation. The book was
published in December 1944, shortly after the
liberation of Paris.

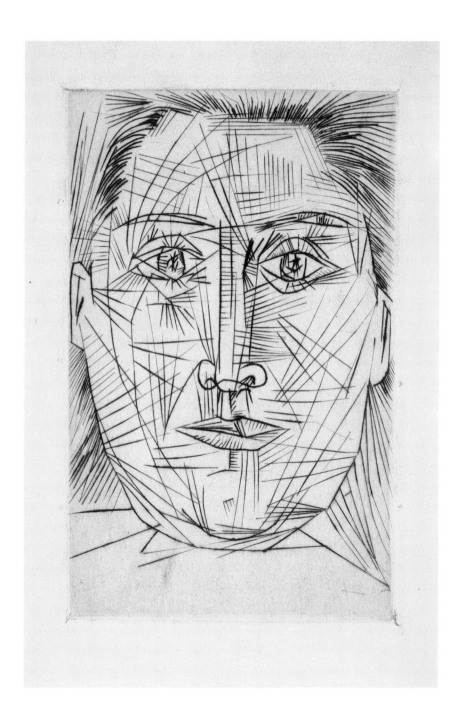

45
Seated Woman,
23 December 1943 (published 1944)

[Femme assise]
Etching in book, 24.6 × 13.2cm plate;
29 × 19cm sheet
Scottish National Gallery of Modern Art
A.42.0268; bequeathed by Gabrielle Keiller 1995

This etching appeared as the frontispiece in
Robert Desnos's book *Contrée*, which was pub-
lished in May 1944. Picasso and Desnos had
known each other since the 1920s, and during the
war they met regularly. Desnos was arrested by
the Gestapo in February 1944, before the book
was published in May. He was deported and died
fifteen months later. Brigitte Baer notes that
Desnos's wife, Youki, had to beg Picasso to
provide the etching, which he seems to have been
loath to hand over. Baer suggests that Picasso was
reluctant to be seen to be affiliating too closely
with a leading member of the Resistance (see
Nash 1998, p.85).

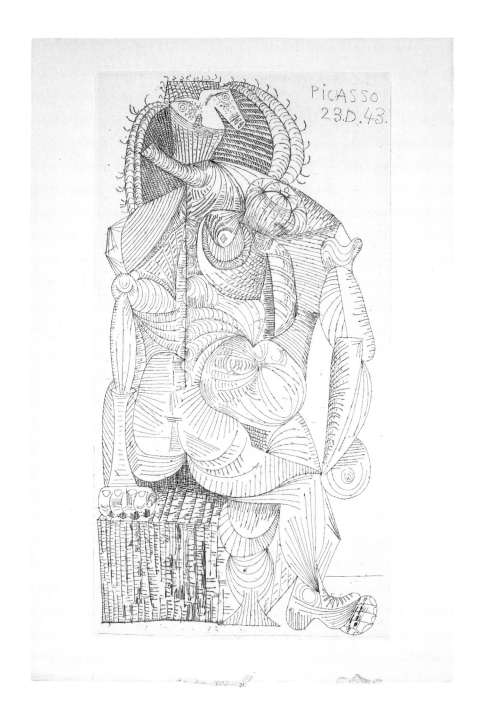

46
**Six Fantastic Stories, 1944
(published 1953)**

[Six Contes fantasques]
Six engravings, each 33.1 × 25cm sheet
Staatsgalerie Stuttgart, Graphische Sammlung
Inv. D 54/71
Illustrated: plate 1

The project to publish an edition of Maurice
Toesca's *Six Contes fantasques* dates back to
February 1943, when the author and the
publisher Flammarion visited Picasso several
times. Picasso made the engravings in 1944, but
the book was not published until 1953. Three of
the engravings feature straightforward portraits
of Dora Maar, two feature more abstract repre-
sentations of a figure, and the first print features
both types.

47
Head of a Woman Wearing a Hat,
9 January 1945

[Tête de femme au chapeau]
Etching in book, 16.5 × 10.8cm plate;
22.6 × 14.2cm sheet
Scottish National Gallery of Modern Art
A.42.0297; bequeathed by Gabrielle Keiller 1995

René Char's book *Le Marteau sans maître*
(The Hammer without a Master) was first pub-
lished in 1934 with an illustration by Kandinsky.
Picasso liked the book and was happy to provide
this etching for its second edition, published in
1945. The etching was included in the first
twenty-five copies of the book.

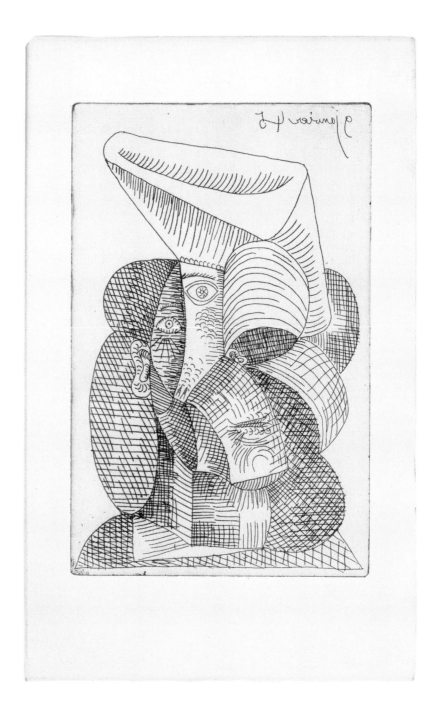

48

[a] The Bull, 5 December 1945

[Le Taureau]
Brush and pen and ink lithograph with scraper
32.6 × 44.3cm sheet
Staatsgalerie Stuttgart, Graphische Sammlung
Inv. A 92/6595 1–11

[b] The Bull, 12 December 1945

[Le Taureau]
Brush and pen and ink lithograph with scraper
32.4 × 44.4cm sheet

[c] The Bull, 18 December 1945

[Le Taureau]
Brush and pen and ink lithograph with scraper
32.5 × 44.4cm sheet

[d] The Bull, 22 December 1945

[Le Taureau]
Brush and pen and ink lithograph with scraper
32.6 × 44.4cm sheet

[e] The Bull, 24 December 1945

[Le Taureau]
Brush and pen and ink lithograph with scraper
32.7 × 44.5cm sheet

[f] The Bull, 28 December 1945

[Le Taureau]
Brush and pen and ink lithograph with scraper
32.6 × 44.2cm sheet

[g] The Bull, 28 December 1945

[Le Taureau]
Brush and pen and ink lithograph with scraper
32.5 × 44.3cm sheet

[h] The Bull, 2 January 1946

[Le Taureau]
Brush and pen and ink lithograph with scraper
32.5 × 44.3cm sheet

[i] The Bull, 5 January 1946

[Le Taureau]
Brush and pen and ink lithograph with scraper
32.6 × 44.5cm sheet

[j] The Bull, 10 January 1946

[Le Taureau]
Brush and pen and ink lithograph with scraper
32.6 × 44.4cm sheet

[k] The Bull, 17 January 1946

[Le Taureau]
Brush and pen and ink lithograph with scraper
32.6 × 44.4cm sheet

Picasso made about thirty lithographs in the 1920s: most of them are variants of his drawings (see cat.16). That approached changed in November 1945, when Picasso began working in the lithography studio of Fernand Mourlot (1895–1988) in the rue de Chabrol, near the Gare de l'Est. Encouraged by Mourlot, Picasso adopted a more painterly approach. This remarkable series of eleven lithographs of a bull, which becomes progressively more stripped down and stylised, was begun on 5 December 1945 and finished on 17 January 1946. At first Picasso made a wash drawing on the lithographic stone. A week later he reworked it extensively. Over the next month he reworked the image again and again, using a pen, brush and scraper. It seems that some of the drawings were done on new stones while others were reworkings of the old stone. Once Picasso had finished reworking each image, Mourlot printed eighteen copies of that state (a few proof copies of additional, intermediate states also exist). Fifty copies of the final, most reduced image were printed. The use of the pen and the scraper was very unusual in lithography, but was typical of Picasso's inventive, almost irreverent approach. The practice of constantly reworking and reducing an image was something Picasso had developed in his painting, for example in *Guernica* which changed constantly over several months. In his paintings Picasso could only record the changing states in photographs, but in printmaking he could keep each separate image. While working on the lithographs, Picasso also made a gouache painting on the same theme (Musée Picasso, Paris, MP.1339). Dated 24–5 December, it must have been made when he was unable to work at Mourlot's studio because of the Christmas break. Picasso hated holidays because they interrupted his work pattern.

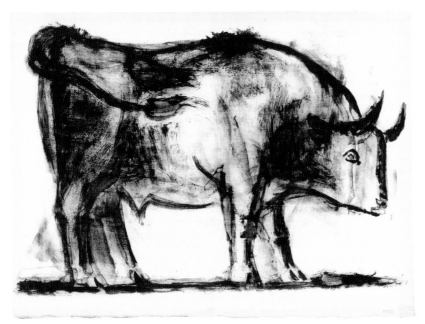

48 [a]

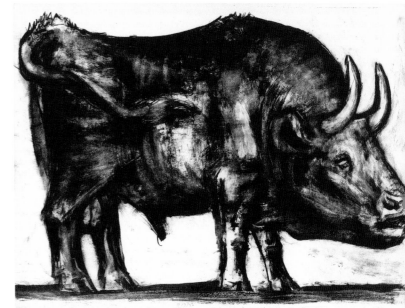

48 [b]

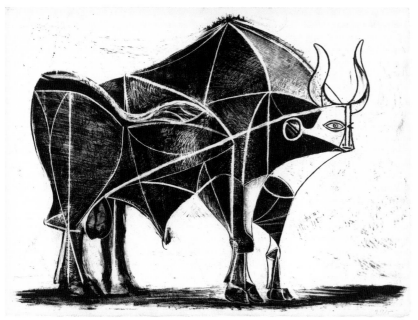

48 [e]

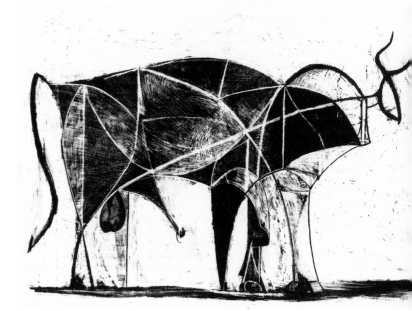

48 [f]

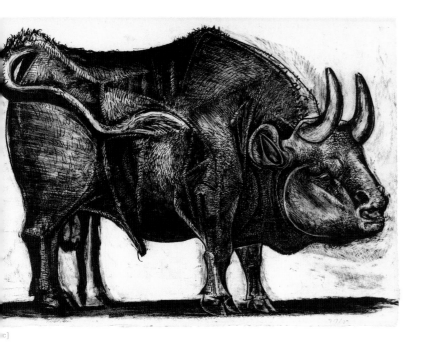

c]

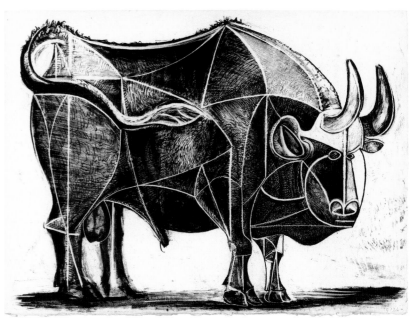

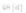

48 [d]

g]

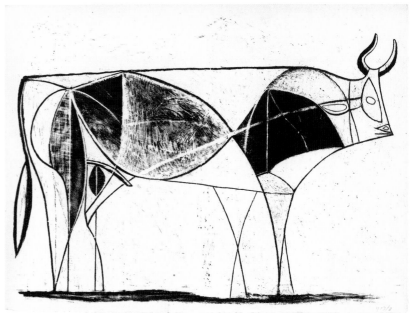

48 [h]

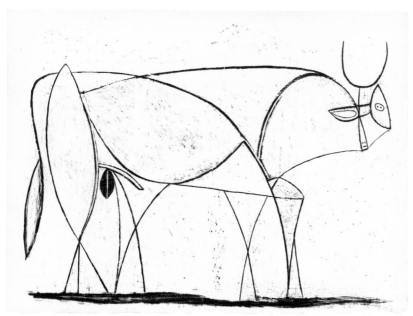

48 [i]

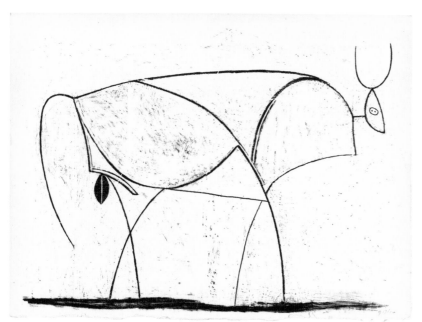

48 [j]

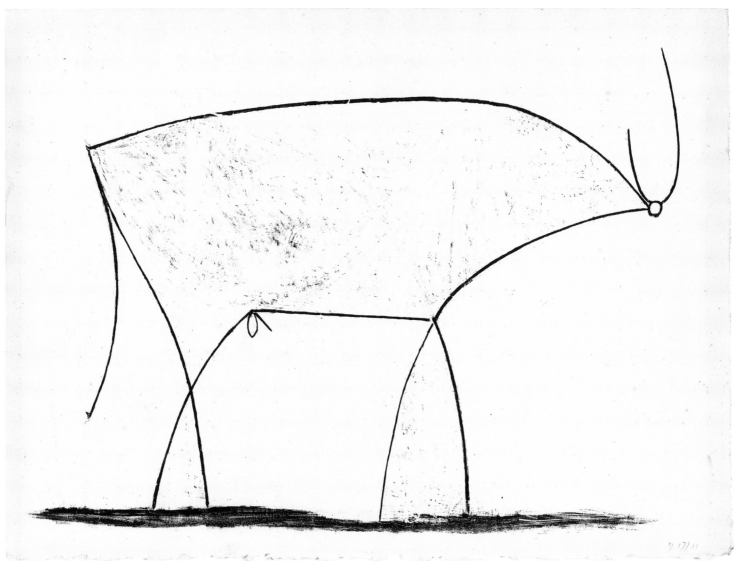

48 [k]

49
Studies of Bulls, 18 January 1946

[Etudes de taureaux]
Pencil with collage, 21.6 × 34.7cm
Staatsgalerie Stuttgart, Graphische Sammlung
Inv. c 94/4395

This drawing was made on 18 January 1946, the day after Picasso had finished work on the series of lithographs of a bull (cat.48). Having reduced the bull from a bulky animal to a scaffolding of lines, Picasso here turned the lines into a maquette for a sculpture, seen from the side and the front. The collaged sheet in the centre was cut out of the final version of the lithograph: it shows the shadow under the bull's head, above which Picasso has drawn a variant of the same stylised animal.

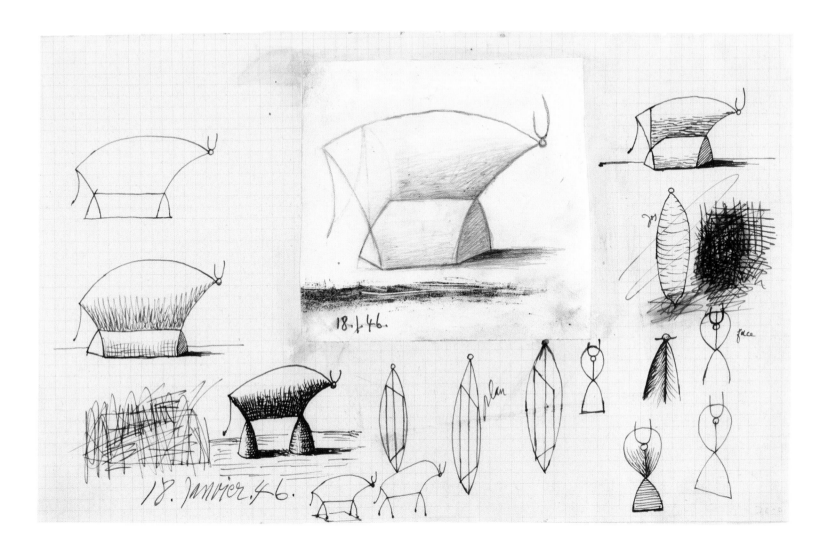

18.1.46.

18. Janvier. 46.

50

Françoise with a Bow in her Hair, 14 June 1946

[Françoise au nœud dans les cheveux]
Lithograph, 63.2 × 47.7cm; 66 × 50cm sheet
Staatsgalerie Stuttgart, Graphische Sammlung
Inv. GL 3386, Deschler, extended loan

Françoise Gilot was born near Paris in 1921.
Initially a law student, she began studying art in
the late 1930s and from 1942 studied at the
Académie Ranson. She met Picasso at a
restaurant in May 1943 and at his invitation
visited him at his studio on the rue des Grands-
Augustins. Their relationship was slow-burning:
she only moved in with him in 1946. This work,
dated 14 June 1946, is one of a series of eleven
lithographic portraits. Gilot recalled that she
began by posing nude and that Picasso studied
her intently without actually drawing her: 'The
following day Pablo began, from memory, a
series of drawings of me in that pose. He made
also a series of eleven lithographs of my head and
on each one he placed a tiny mole under my left
eye and drew my right eyebrow in the form of a
circumflex accent' (Gilot 1964, p.112).

Picasso and Gilot had two children, Claude and
Paloma. With his encouragement, she developed
into a noted painter, having a number of major
exhibitions. Gilot and Picasso separated in 1953.
Her memoirs of their relationship, *Life with
Picasso*, published in 1964, caused an acrimoni-
ous and irrevocable split. Alone among Picasso's
mistresses, Gilot left on her own terms and man-
aged to establish an independent life, largely free
from his shadow. Her memoirs were much
derided by Picasso's circle when they were
published, but they are now regarded as a vital
and accurate source of information on the artist.

51
**Portrait of Françoise with Wavy Hair,
24 June 1947**

[Portrait de Françoise aux cheveux flous]
Aquatint with sugarlift, 61.3 × 45.3cm plate;
66.5 × 50.4cm sheet
Staatsgalerie Stuttgart, Graphische Sammlung
Inv. A 66/4314

This lithograph dates from 24 June 1947,
just a month after Françoise had given birth to
her first child, Claude.

52

Deux contes, 1948

[Two Stories]
Book with four drypoints, 32.5 × 25.5cm sheet
Scottish National Gallery of Modern Art
A35/2/RPL1/001; purchased with assistance from
the National Heritage Memorial Fund and The
Art Fund 1994
Illustrated: title page with original drawing and
second drypoint

Ramón Reventós had been Picasso's friend in Barcelona in the 1890s. He became a writer, but his premature death in 1923 meant that his work, written in Catalan, remained largely unknown. When the publisher Ferran Canyameres told Picasso he wanted to print some *beaux-livres* in Catalan, Picasso suggested his late friend's *Dos contes* (Two Stories), for which he would provide four engravings. The book appeared in the spring of 1947 and, encouraged by its success, the publisher produced a French version with a new translation and four completely different drypoint etchings. The text was printed in the summer of 1947, but Picasso did not produce the illustrations until February 1948. The mythological subject matter of the text (the 'Two Stories' are 'The Centaur Picador' and 'Twilight of a Faun') was in tune with the work Picasso was

making at the Château Grimaldi in Antibes from 1946, and may have inspired Picasso's other work there. This copy of the book contains a drawing by Picasso of a centaur and several other rapid sketches in ballpoint pen: dated 19 August 1951, they were done especially for Lee Miller and her husband, Roland Penrose.

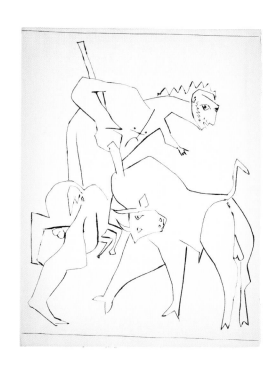

53

Le Chant des morts, 1948

[The Song of the Dead]
Book with 125 lithographs, 42.5 × 65 (open page size)
Scottish National Gallery of Modern Art
A.35/2/RPL1.0011; purchased with assistance from the National Heritage Memorial Fund and The Art Fund 1994
Illustrated: title page

This book, a collaboration between Picasso and the poet Pierre Reverdy, was commissioned and published by Elf Tériade. Picasso and Reverdy were old friends: Picasso contributed three etchings for Reverdy's book *Cravates de chanvre*, published in 1922. Reverdy finished writing *Le Chant des morts*, a series of forty-three poems, early in 1945. Picasso originally intended to provide traditional illustrations but changed his mind when he saw the author's handwritten manuscript. Picasso described Reverdy's writing as being like a drawing and he decided to decorate it in the manner of medieval manuscripts. Roland Penrose relates that a book-dealer brought Picasso three such manuscripts and that Picasso was particularly struck by a very early one in which the black text was complemented by large red ornamental initials (Penrose 1981, pp.188–9). Picasso made his illustrations in the south of France. The printer Mourlot transferred Reverdy's texts onto zinc lithographic plates in Paris, took them down to Antibes, and Picasso painted the decorative designs directly onto the plates. Picasso finished work on the project in March 1948 and the book was published in September. Picasso regarded it as one of his favourite book projects.

54
Vingt poèmes de Góngora, 1948

[Twenty Poems by Góngora]
Book with forty-one etchings, sugarlift
aquatints and drypoints, each
37.5 × 27.5cm sheet; and a drawing in coloured
ink, 1950
Scottish National Gallery of Modern Art
A.35/2/RPL1/0010; purchased with assistance
from the National Heritage Memorial Fund
and The Art Fund 1994
Illustrated: title page and one aquatint

Having just finished *Le Chant des morts*
(cat.53), with its combination of handwritten
text and images, Picasso copied out twenty
sonnets by the seventeenth-century Spanish
poet Luis De Góngora y Argote and then filled
the margins with elaborate little sketches. Each
poem is preceded by a full-page etching: these
comprise one portrait of Góngora based on a
painting by Velázquez and a sequence of nine-
teen female heads. Like *Le Chant des morts*,
Picasso executed these works in the south of
France. The printer Roger Lacourière prepared
the copper etching plates in Paris and Picasso
painted directly onto them using the sugarlift
aquatint technique. Françoise Gilot provides a
detailed account of this process in her memoirs
of her life with Picasso (Gilot 1964, pp.184–5).
Many of the portraits represent Gilot, al-
though one is extraordinarily like Picasso's
future wife, Jacqueline, whom he had not
yet met.

The title page of this copy of the book
features a splendid coloured ink drawing of a
satyr on a horse; Picasso drew it in London on
15 November 1950 and dedicated it to Roland
Penrose. Picasso was attending the World Peace
Conference in Sheffield and stayed with
Penrose in London before the conference and
then at his farm in Sussex.

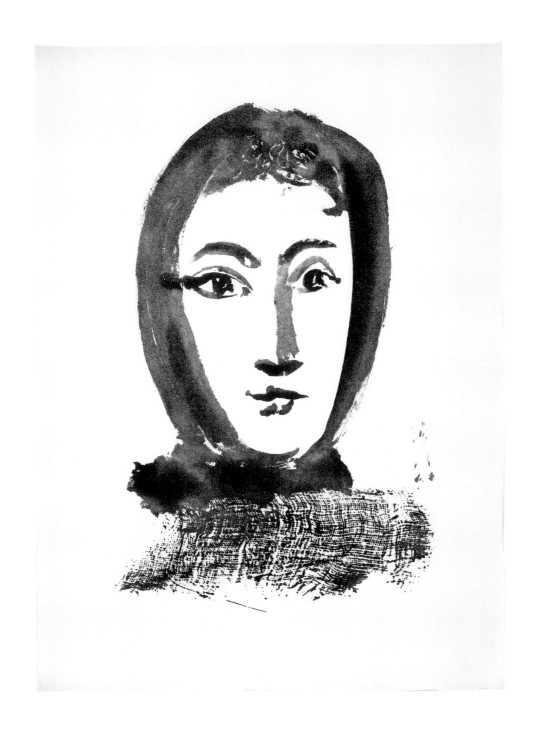

55

The Big Owl, 10 March 1948

[Le grand hibou]
Lithograph, 76 × 56.2cm sheet
Staatsgalerie Stuttgart, Graphische Sammlung
Inv. A 64/2720

In order to get Picasso to finish work on *Le Chant des morts* (cat.53), the printer Mourlot had taken a group of zinc lithographic plates down to the south of France for the artist to work on. Mourlot relates: 'But there were seven zincs too many and some lithographic ink remained; on the same day seven compositions were therefore made' (Mourlot 1970, n.p.). These seven compositions comprised *The Big Owl* and six of fauns playing musical instruments (cat.56). Picasso's father was a great lover of birds, keeping pigeons in a dovecot and even allowing them to fly around the family home. Picasso did likewise; he even named his daughter after the Spanish word for dove, Paloma.

In November 1946, while working at the Château Grimaldi in Antibes (a museum where he was offered studio space and invited to provide decorative murals: it is now a Picasso Museum), Picasso was handed an injured owl. He tended it and made a splint for its broken leg. Lionel Prejger, an acquaintance who later collaborated with Picasso, recalled that the artist then gave it to him, and that he nursed it back to health before returning it to Picasso in Paris in 1948 (Cowling and Golding 1994, p.241). Françoise Gilot gives a slightly different account, claiming that she and Picasso nursed it back to health in Paris and that they trapped mice in the studio to feed to it. She also adds that they kept the owl in the kitchen, along with pigeons, turtledoves and canaries (Gilot 1964, pp.143–4). Whatever the case, the owl became a recurrent motif in Picasso's art, appearing first in November 1946 and then regularly in the early months of 1947. Picasso called the owl Ubu, a pun on the French word for owl, 'hibou', and in reference to Alfred Jarry's Père Ubu character. Picasso often returned to the owl image in the late 1940s and in sculptures and ceramics in the early 1950s.

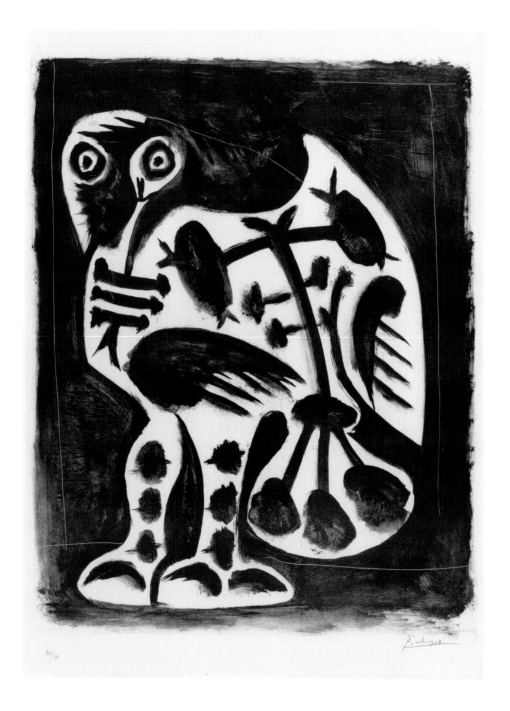

56
Musician Faun No.3, 10 March 1948

[Faune musicien No. 3]
Lithograph, 76.6 × 56.5cm
Staatsgalerie Stuttgart, Graphische Sammlung
Inv. A 52/1107

The image of a faun appears sporadically in Picasso's work of the inter-war period (see for example cat.32) but became a recurrent motif from 1946. In July 1945 Picasso and Dora Maar had visited the Cap d'Antibes together. Soon after returning to Paris, Picasso made a few works featuring a faun playing pan-pipes. It is not clear how or why Picasso started to use this motif: he may have been inspired by Matisse who had painted similar figures earlier in his career. Picasso returned to the theme in the summer of 1946, when he took up the invitation to decorate the Château Grimaldi in Antibes. He was immediately inspired by ancient mythology. One of the most important works he painted at this time, *The Joy of Life*, featured mythological beasts including a centaur and a faun playing pipes. Many other drawings and prints of the time (including *Deux contes*: cat.52) feature the same beasts. Commenting on this new subject matter Picasso said: 'It is strange that in Paris I never draw fauns, centaurs or mythological heroes like this. You would think that they only exist here.' M. Dor de la Souchère, the curator of the Château Grimaldi, was equally vague regarding the source of the image, writing to Picasso: 'I consider that the image of the faun who plays the flute … came to you by destiny, in order to represent the protective divinities of the Museum in Antibes' (Sabartés 1948, p.31). This lithograph was one of seven prints made on spare zinc plates which the printer Fernand Mourlot had brought down to the south of France as part of the *Chant des morts* (cat.53) project, but which remained unused. One of the plates was used for *The Big Owl* (cat.55) and the other six for different *Musician Fauns*. In the early 1950s Picasso made a major series of ceramics and linocuts depicting fauns playing pipes.

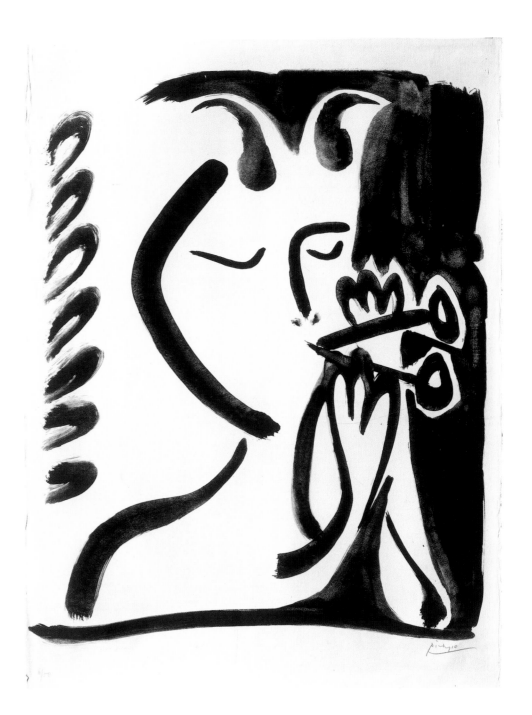

57

Head of Bull Facing Left, 1948

[Tête de taureau, tournée à gauche]
Lithograph, 64.5 × 49.7cm image;
65.5 × 49.7cm sheet
Staatsgalerie Stuttgart, Graphische Sammlung
Inv. A 52/1106

This is one of a pair of similar prints dating from November 1948. After the Second World War, Picasso spent increasing amounts of time in the south of France, buying the villa 'La Galloise' at Vallauris, between Cannes and Antibes, in 1948. He was attracted to the Riviera for several reasons, including the weather, the peace and the bullfights. Bullfights were held in the summer in Vallauris in a portable ring; nearby, Arles and Nîmes had major bullrings. The prominence of bullfighting imagery in Picasso's postwar work has much to do with this change of scene.

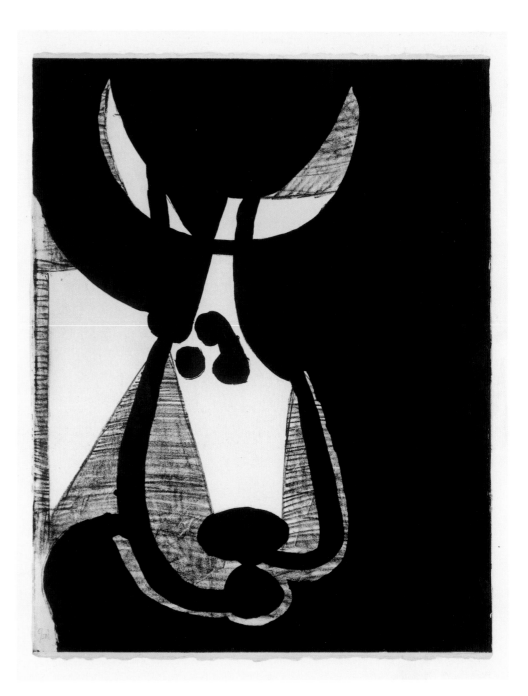

58
Woman in an Armchair
(from the Black), 17 December 1948

[Femme au fauteuil (d'après le noir)]
Lithograph, 69.5 × 54.2cm plate;
76.3 × 55.8cm sheet
Staatsgalerie Stuttgart, Graphische Sammlung
Inv. A 98/6799

At the end of 1945 Picasso turned his attentions
to lithography. He made a few lithographs of
Françoise Gilot in November of that year, but
only returned to her as the main subject of his
printmaking on 14 June 1946, when he pro-
duced a series of lithographs of her head (see
cat.50). In November 1948 he began a more
extensive series of Françoise seated and dressed
in an embroidered Polish coat (earlier that year,
Picasso had attended a Peace Conference in
Warsaw and brought the coat back as a gift).
Picasso began by making a five-colour litho-
graph, employing a separate zinc plate for each
colour. He was unhappy with the results and
subsequently reworked the plates, printing each
of them in black. The subtitle of this print 'From
the Black' means that this image is a reworking
of the black plate in the original colour litho-
graph. There are more than thirty works in this
series. Françoise Gilot recalled: 'He did the
series of lithographs of me called *Portrait with
a Polish Coat*. None of them were very natural-
istic and some seemed a continuation of the
rhythms he had explored in his illustration of
Reverdy's *Le Chant des morts*: long, linear
signs, rounded at the ends' (Gilot 1964, p.215).
As with almost all of Picasso's portraits of this
time, they were done from memory. The rhyth-
mic patterns almost certainly betray the
influence of Matisse, who lived not far away on
the Côte d'Azur. Picasso and Françoise visited
him on several occasions in the immediate
postwar years.

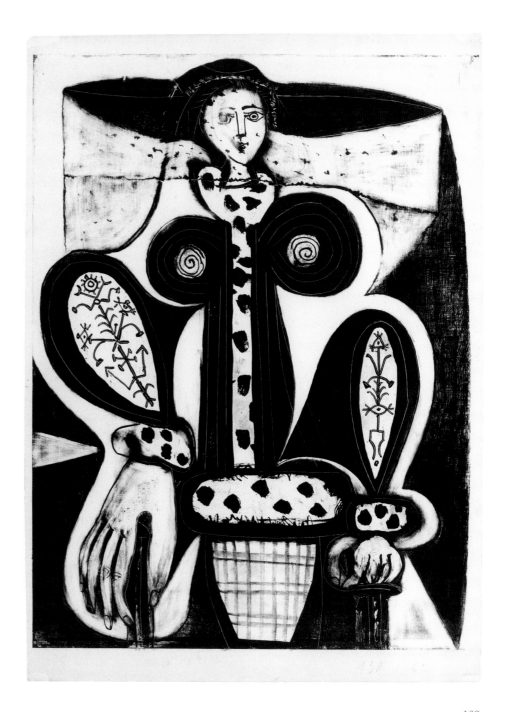

59
Woman in an Armchair No. 1
(from the Red), 17 January 1949

[Femme au fauteuil No. 1 (d'après le rouge)]
Lithograph with scraper, 69.6 × 54.7cm plate;
76.5 × 56.7cm sheet
Staatsgalerie Stuttgart, Graphische Sammlung
Inv. A 52/1019
Although this print is entitled 'No.1', it is not the
first in this series. It is a reworked version of the
red plate originally made for a colour lithograph
(see cat.58).

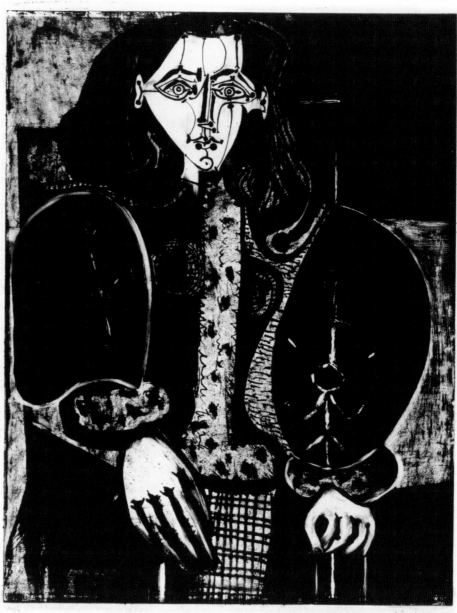

60
Woman in an Armchair (Variant), 1949

[Femme au fauteuil (variante)]
Lithograph, 69.7 × 54.7cm plate;
76.5 × 56.6cm sheet
Staatsgalerie Stuttgart, Graphische Sammlung,
Inv. A 04/7279

This is an unusual 'collaged' variant of one of the
lithographs from the *Woman in an Armchair*
series (see cats.58–9). The original head has been
blanked out and over-printed with a completely
different portrait of Françoise, which Picasso had
made as an independent print in February 1949.
Although out of scale and wearing different
clothes, the new head somehow fits the body.
This variant dates from February or March 1949.

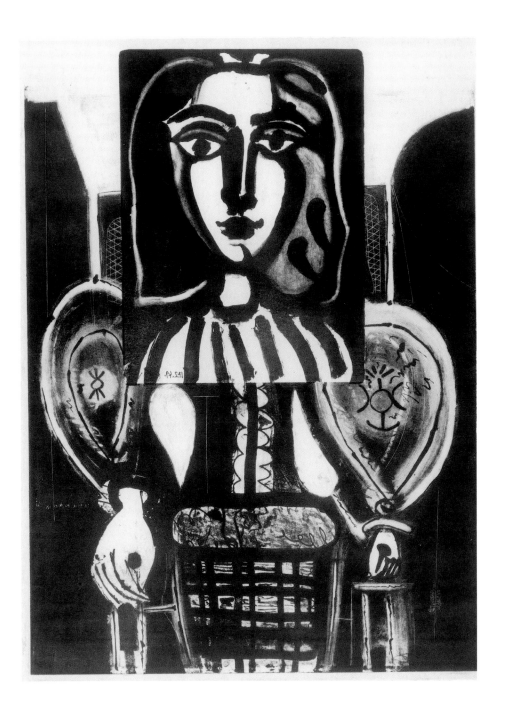

61

The Toad, 13 January 1949

[Le Crapaud]
Lithograph, 50 × 65.5cm
Staatsgalerie Stuttgart, Graphische Sammlung
Inv. A 53/1500

Picasso drew and painted an extraordinarily wide variety of beasts and birds. Françoise Gilot commented: 'Picasso loved to surround himself with birds and animals. In general they were exempt from the suspicion with which he regarded his other friends' (Gilot 1964, p.143). This print was made on 13 January 1949. Picasso drew it on special transfer paper and the image was then transposed onto a zinc lithographic plate for printing. This technique allowed Picasso to produce lithographs at his own studio in the rue des Grands-Augustins. He would often work at Fernand Mourlot's lithography studio in the north of Paris during the day, take the transfer paper home, produce more work in the evening, and then print it at Mourlot's studio the next day.

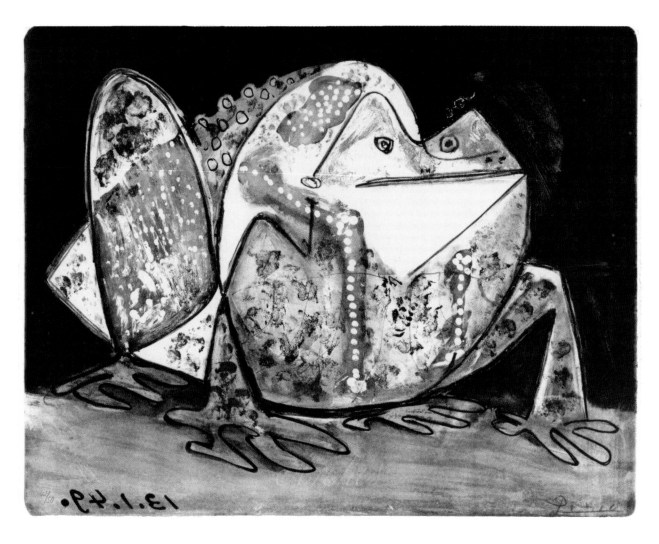

62
David and Bathsheba, 29 May 1949

[David et Bethsabée]
Lithograph with scraper, 65.6 × 50.1cm image;
66.1 × 49.2cm sheet
Staatsgalerie Stuttgart, Graphische
Sammlung Inv. A 51/1010

In 1946 Picasso selected ten paintings for
donation to the French state. They were
taken, temporarily, to the Louvre, and on a
Tuesday, when the museum was closed,
Picasso spent several hours 'testing' them
against the great masters of the past. This
event provided an important stimulus for
Picasso, and in the following years, he 'took
on' the old masters, making hundreds of
variants after Delacroix, Manet, Velázquez
and Cranach (the Younger as well as the
Elder) in particular.

Here, the subject comes from Lucas
Cranach the Elder's painting *David and
Bathsheba*, 1526, in the Staatliche Museen
zu Berlin-Preussicher Kulturbesitz. Picasso
produced numerous lithographic variants on
the painting between March 1947 and May
1949. He seems to have been obsessed with
the image, and the printer Fernand Mourlot
reported that he only stopped work on it in
1949 because he had to leave for the south of
France. The original painting and Picasso's
versions show David watching Bathsheba as
she bathes. Picasso shifted the figures around
considerably, and through the printing
process the image becomes reversed. There
are ten different states of the print, which had
a very complicated genesis: it was begun as a
lithograph on zinc, but was eventually
transferred to a lithographic stone. Commen-
tators have often identified David with
Picasso: he watches Bathsheba, who in turn
resembles Françoise Gilot.

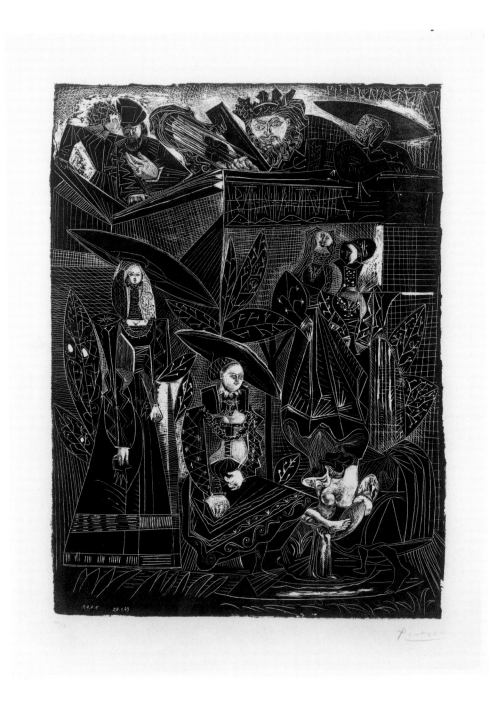

63
**Paloma and Claude, Vallauris,
16 April 1950**

[Paloma et Claude, Vallauris]
Two lithographs, mounted together, 32 × 27cm
and 32 × 24cm each sheet
Staatsgalerie Stuttgart, Graphische Sammlung,
Inv. A 66/4453 a & b

In 1948 Picasso acquired a villa in Vallauris, near Cannes in the south of France. He moved in with Françoise Gilot and their son Claude, who was born in May 1947. Their daughter Paloma was born in April 1949. This pair of lithographs was made on 16 April 1950, just three days before Paloma's first birthday. They were made as the front and back covers for the second volume of Fernand Mourlot's catalogue raisonné of Picasso's lithographs. Mourlot later explained: 'I went to see Picasso at Vallauris to show him the final proofs and obtain the cover lithograph. "You shall have it tomorrow, Mourlot." And indeed, the next day, he shut himself up in the workshop and set to work. Picasso had neither a greasy litho crayon nor a brush, but he found a way round this difficulty. He put some water into the litho ink container and with his finger thinned the solidified ink. In this way he completed the extraordinary life-like portraits of his children' (Mourlot 1970, n.p.). By using his fingers, Picasso achieved a soft, playful quality entirely appropriate to the subject. Picasso had two other children: Paulo, born in 1921 to Olga Khokhlova; and Maya, born in 1935 to Marie-Thérèse Walter.

64
Corps perdu, 1949 (published 1950)

[Lost Body]
Thirty-two etchings and engravings, some with
aquatint and drypoint, each 39 × 28.4cm
Staatsgalerie Stuttgart, Graphische Sammlung
Inv. D 61/207
One etching illustrated

In 1941 André Breton and the Cuban painter
Wifredo Lam went to the West Indies: there they
met the Martiniquan poet Aimé Césaire. It is not
clear how Picasso came to be asked to illustrate
Césaire's *Corps perdu*. It has been suggested that
Breton recommended Picasso (Goeppert 1983,
p.156), but the two were not on good terms at
the time, owing to Picasso's allegiance to the
Communist Party. The etchings and engravings,
which were done in March 1949, depict plants,
insects, pictographic images of copulating
couples, and faces in the form of leaves, animals
and crescent moons. The book was published in
1950 in an edition of 219 copies.

65

Balzac, 25 November 1952

Lithograph, 68.8 × 51.4cm image;
75.9 × 56.6cm sheet
Staatsgalerie Stuttgart, Graphische Sammlung
Inv. A 74/5321

This is one of eleven portraits of Balzac which
Picasso made in a single day. The publisher André
Sauret commissioned a portrait of the author for
the frontispiece of a new edition of *Le Père
Goriot*. Picasso began work on the portraits the
day he learned of the commission. He made eight
small portraits (one of which was used in the
book) and three larger ones, including this one.
Picasso was a great admirer of Balzac's writing.
In 1927–9 he had worked on illustrations for
Balzac's *Le Chef-d'oeuvre inconnu* (cat.18).

66

**Paloma and her Doll,
Black Background, 14 December 1952**

[Paloma et sa poupée, fond noir]
Lithograph with scraper, 70.3 × 55.6cm
image; 73 × 55.9cm sheet
Staatsgalerie Stuttgart, Graphische Sammlung
Inv. A 53/1508

Paloma (Spanish for dove) was born on 19 April
1949. Of all Picasso's children, she is the one who
emerged most successfully from his shadow,
forging her own career in fashion and perfumes.
This is one of a number of lithographs and
drawings of Paloma and Claude made by Picasso
between December 1952 and January 1953.

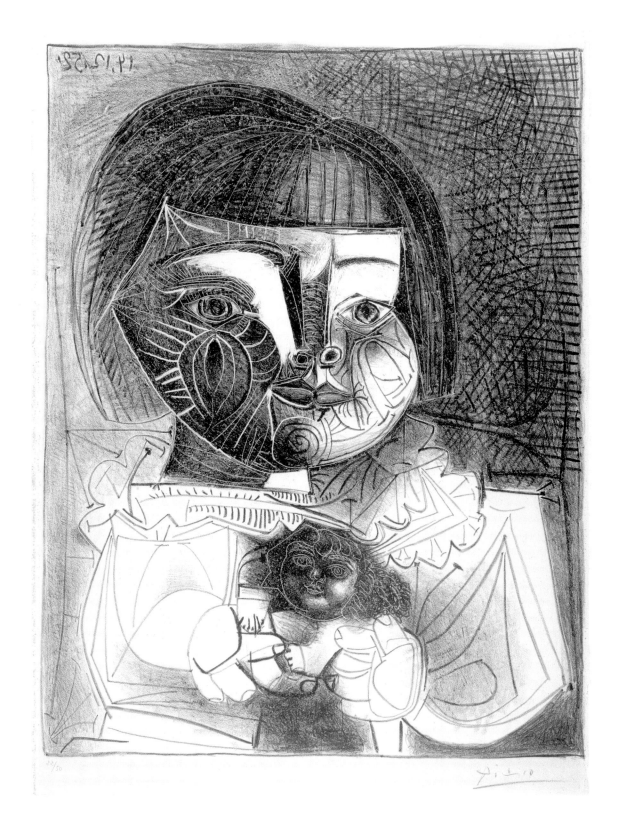

67

Goat's Skull, 14 May 1952

[Crâne de chèvre]
Aquatint with sugarlift, 47.6 × 64.3cm plate;
56.4 × 73.5cm sheet
Staatsgalerie Stuttgart, Graphische Sammlung
Inv. A 53/1246

Goats became a major theme in Picasso's work in 1950, the year he and Françoise Gilot won a goat in a lottery at Vallauris. Picasso became closely attached to the animal, allowing it free rein of his villa; he also liked to take it for walks on a lead. Gilot was less fond of it and a few months later she gave it away to some gypsies (Gilot 1964, pp.222–3). Picasso was furious and later acquired another goat. The goat inspired a celebrated sculpture which Picasso assembled from various found parts, including a wicker basket which formed the animal's body (this was a she-goat, whereas Picasso's own goat was decidedly male). Picasso turned to the theme of the goat's skull in 1951–3 when he made a sculpture of the skull standing next to a bottle containing a lit candle (Museum of Modern Art, New York), and in a painting of the same subject done in 1952 (Tate, London). The skull and candle are classic *vanitas* images, symbolising the transience of life, and that sentiment is echoed in this print and cat.68.

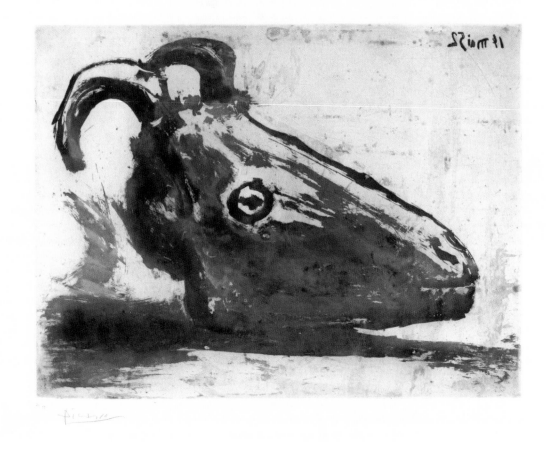

68

Goat's Skull on the Table, 20 January 1953

[Crâne de chèvre sur la table]
Etching and aquatint, 51.6 × 66.7cm plate;
56.6 × 75.8cm sheet
Staatsgalerie Stuttgart, Graphische Sammlung
Inv. A 53/1501

This is the third state of an etching Picasso made over three days, from 17 to 20 January 1953. It has its origins in a painting by Picasso, which Roger Lacourière reproduced as an etching, and which Picasso then reworked.

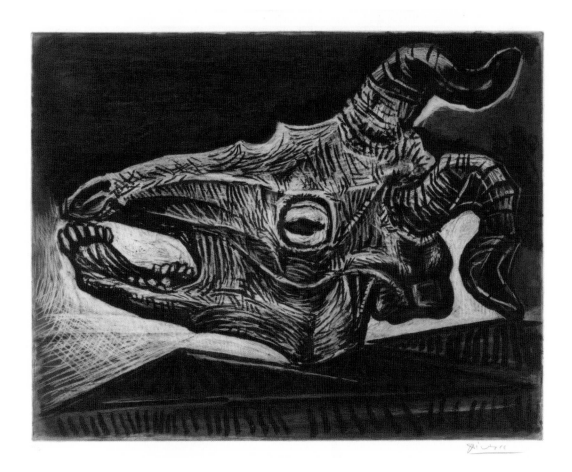

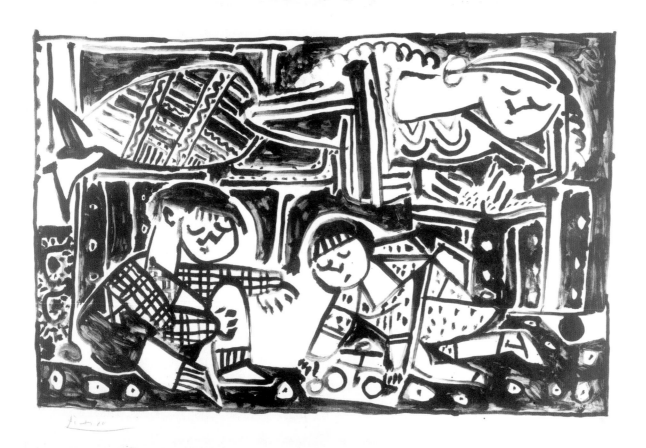

69
**Mother and her Children,
20 January 1953**

[La Mère et les enfants]
Lithograph, 56.5 × 76.3cm image;
48.2 × 75.2cm sheet
Staatsgalerie Stuttgart, Graphische Sammlung
Inv. A 56/1825a

This lithograph was executed on the same day as *Goat's Skull on the Table* (cat.68). It shows Françoise Gilot with Claude and Paloma (see cat.63). In common with other depictions of his children, here Picasso adopts a simplified style that owes something to children's drawings. In an essay on Picasso's depictions of his family, Michael FitzGerald notes that the images which include Françoise show her somewhat distanced from the children: 'Lying on a couch or seated at a table, she is physically close to them, yet intellectually detached and elevated above their arena of the floor' (in Rubin 1996, p.431). By this date Picasso's relationship with Gilot was drawing to an end. This lithograph dates from January 1953, when Picasso was alone in Paris: it is therefore an imagined, idealised scene. Later that year, Françoise left Picasso: she moved out of the villa in Vallauris and back to Paris, taking the children with her.

70
The Egyptian, 11 May 1953

[L'Egyptienne]
Aquatint, 83.5 × 47.4cm plate;
91.2 × 63.7cm sheet
Staatsgalerie Stuttgart, Graphische Sammlung
Inv. A 54/1630

In the early 1950s Picasso developed an idiosyn-
cratic painting style involving a complex network
of black lines, often with big dots at the ends, and
with the shapes in between picked out in colour.
The style probably originated in Picasso's draw-
ings, and carried through into the prints, as seen
in the *Chant des morts* illustrations (cat.53).
Picasso almost never titled his prints: the titles
were generally given by the print workshop, art
historians or his dealer. This is a portrait of
Françoise. In reference to her hairstyle, which
resembled an Egyptian head-dress, it was
referred to as *The Egyptian* at Roger Lacourière's
print studio, where the print was made. This is
one of Picasso's last depictions of Françoise.

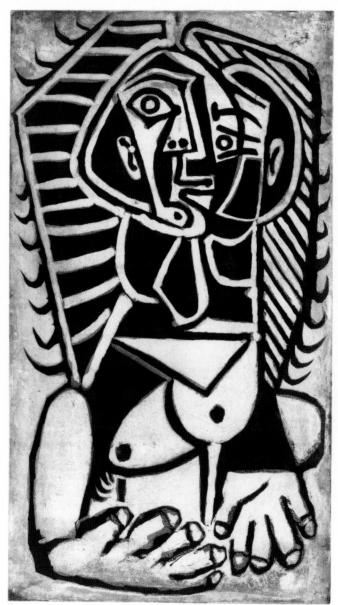

71

**The Painter on the Beach,
5 February 1955**

[Le Peintre sur la plage]
Aquatint with sugarlift, 47.2 × 83.2cm plate;
63.2 × 91cm sheet
Staatsgalerie Stuttgart, Graphische Sammlung
Inv. A 55/1797

The subject of the painter at work appeared in
Picasso's work in the 1920s, most notably in the
etchings he made for Balzac's *Le Chef-d'oeuvre
inconnu* (cat.18). It became one of the dominant
themes of Picasso's late work. It was partly inspired
by Velázquez's *Las Meninas*, one of the great icons
of Spanish art, but it also relates to Picasso's increa-
sing isolation in the south of France and, no doubt,
to his own sense of mortality.

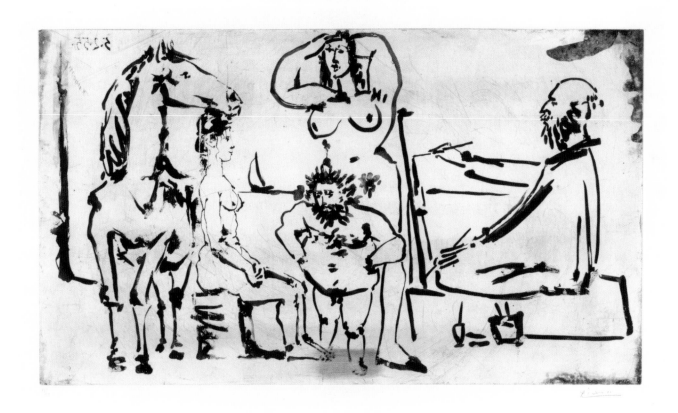

72
Portrait of Daniel–Henry Kahnweiler II, 3 June 1957

[Portrait de Daniel-Henry Kahnweiler II]
Lithograph, 65.2 × 49.3cm image;
66.2 × 50.2cm sheet
Staatsgalerie Stuttgart, Graphische Sammlung
Inv. A 64/2721

Daniel-Henry Kahnweiler (1884–1979) was born in Mannheim, Germany. He trained as a stock-broker but was more interested in art, and in 1907 he set up the Galerie Kahnweiler in Paris. Alongside Ambroise Vollard (see cat.33) he became Picasso's main dealer, but whereas Vollard preferred the artist's more traditional work, Kahnweiler supported Cubism. His gallery stock was sequestered by the French Government during the First World War and sold off at auction in 1921. After the war his Gallery's name changed to the Galerie Simon, and subsequently to the Galerie Louise Leiris. Kahnweiler pub-lished Picasso's prints from 1910 until the artist's death, and indeed published some posthumously. He had grown up in Stuttgart, and had a great affection for the Staatsgalerie: he gave the gallery a number of 'Artist's proof' copies of Picasso's prints, simply sending them through the mail in poster tubes. This is one of three lithographic portraits of the dealer which Picasso made on the same day.

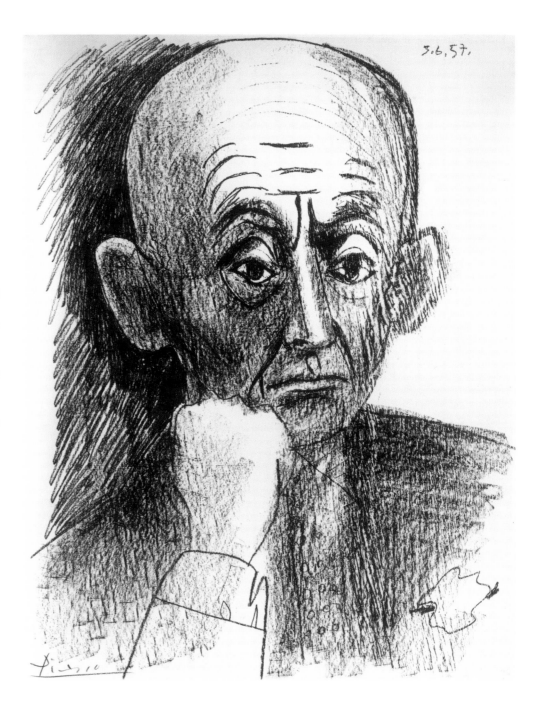

119

73

Jacqueline Reading, 27 December 1958

[Jacqueline lisant]
Lithograph, 55.8 × 44cm image;
65.7 × 50cm sheet
Staatsgalerie Stuttgart, Graphische Sammlung
Inv. A 64/3994

Picasso spent the summer of 1946 working in Antibes, having been invited to set up a studio in the town's museum, the Château Grimaldi. At the request of Suzanne Ramié and her husband Georges, he visited their Atelier Madoura pottery studios at nearby Vallauris. Picasso made a couple of little pottery animals at the time, but he returned the following years to work in earnest, buying a villa in Vallauris in 1948. Jacqueline Roque (1927–1986) was Suzanne Ramié's cousin. A divorcee with a young daughter, she became a sales assistant at Madoura. Jacqueline and Picasso probably first met at the end of 1952, when he was seventy-one and she was in her mid-twenties. By that time his relationship with Françoise Gilot was deteriorating, and Jacqueline quickly replaced her in his affections. They lived together from autumn 1954 and married in March 1961, moving into a house called Notre-Dame-de-Vie in Mougins.

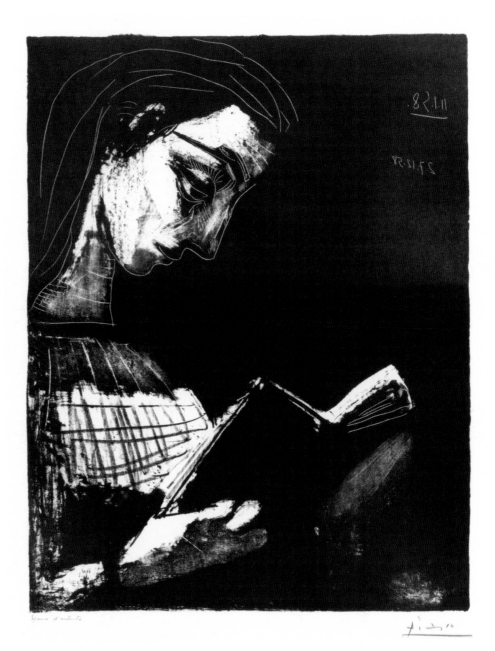

74
Head of Minotaur, 6 May 1958

[Tête de Minotaure]
Brush on Japanese paper, 37 × 27.7cm
Staatsgalerie Stuttgart, Graphische Sammlung
Inv. c 64/1290

This bold brush-drawing and the more linear
Female Nude from Behind (cat.75) were made
on the same day, 6 May 1958.

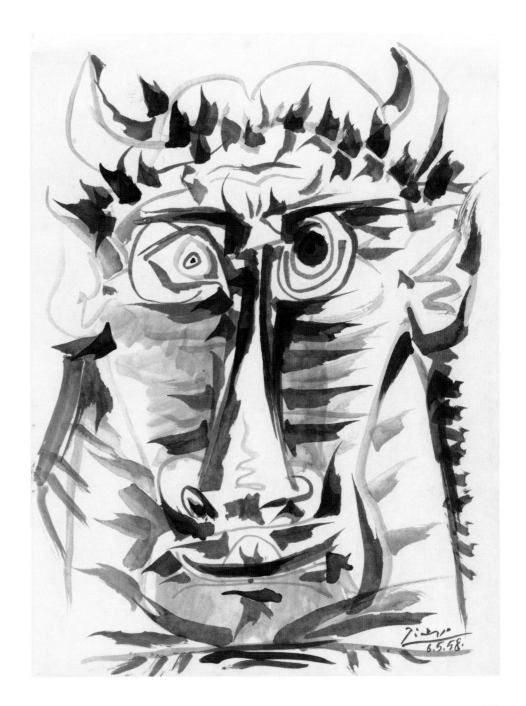

75

Female Nude from Behind, 6 May 1958

[Nu de femme de dos]
Brush on Japanese paper, 32.3 × 24.6cm
Staatsgalerie Stuttgart, Graphische Sammlung
Inv. C 64/1291

76

La Rose et le chien: poème perpétuel par Tristan Tzara, March 1958

[The Rose and the Dog: Perpetual Poem by
Tristan Tzara]
Four engravings with drypoint in cover
28 × 20cm
Staatsgalerie Stuttgart, Graphische Sammlung
Inv. D 86/533
Not illustrated

This is the last of four books by Tristan Tzara
which Picasso illustrated (see also cat.21), and is
the most ingenious. One of the sheets contains
three superimposed discs; two of these are mobile
and when turned, different combinations of
words appear through the apertures in the paper,
thus creating an almost infinite number of
poems. The printer, Pierre André Benoit, claimed
that the small engraving in the centre hides a
secret note in the middle of the third disc which
can only be read by destroying the book. The
scratchy, apparently random markings must have
suited Tzara, one of the first-growth Dadaists.

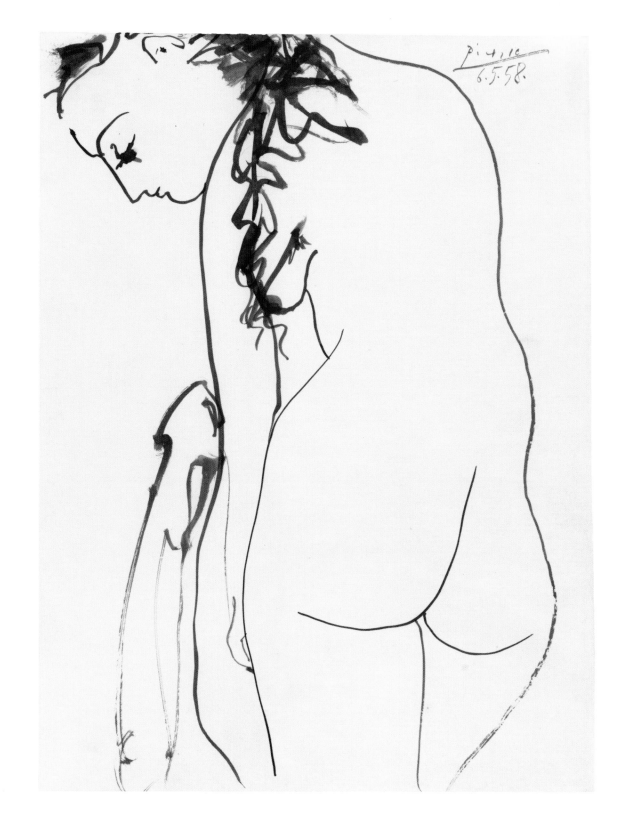

123

77

Portrait of a Young Girl, after Cranach the Younger. II, 4 July 1958

[Portrait de jeune fille, d'après Cranach le jeune. II]
Colour linocut, 64.3 × 52.8cm image;
77.8 × 57cm sheet
Staatsgalerie Stuttgart, Graphische Sammlung
Inv. A 64/4177

Picasso moved to Vallauris, between Cannes and Antibes, in 1948. He worked extensively at the nearby Madoura pottery studios, and from time to time made posters for local exhibitions and bullfights. The first of these posters was produced on the lithographic press of a young printer who worked in Vallauris, Hidalgo Arnéra. At Arnéra's suggestion, in 1951 Picasso began making the posters in linocut, a cheap and straightforward technique. Picasso had made several woodcuts in the early 1900s but only once before had he used linocut, for a minor print made in 1939. During the 1950s he made a number of these linocut posters, often using a single colour or over-printing colours in a simple way.

This portrait, made on 4 July 1958, was Picasso's first independent linocut. It was based on a postcard sent to him by his dealer Daniel-Henry Kahnweiler of a painting by Lucas Cranach the Younger, in the Kunsthistorisches Museum in Vienna. Cranach's painting of 1564 is delicately modelled and coloured, making it an unexpected choice for turning into a linocut. Adopting the conventional technique for colour linocuts, Picasso cut a different linoleum block for each different colour in the print. Here there are five colours (yellow, red, brown, blue and black), so five separate blocks had to be cut. Registering each block correctly was tricky, hence the slight overlaps and gaps between the colours. It was printed by Arnéra and, like nearly all Picasso's linocuts, was published by Kahnweiler's Galerie Louise Leiris in an edition of fifty. This print was given to the Staatsgalerie Stuttgart by Kahnweiler.

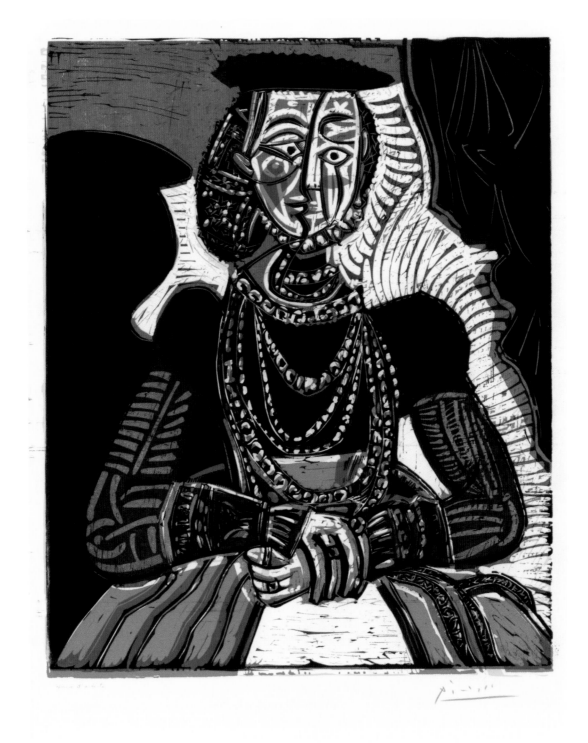

125

78

Bull and Picador, 5–6 September 1959

[Taureau et picador]
Colour linocut, 52.8 × 64cm image;
62.3 × 75cm sheet
Staatsgalerie Stuttgart, Graphische Sammlung
Inv. GL 1181

In the 1950s Picasso spent increasing amounts
of time in the south of France and the business
of sending his etching and lithographic plates
back and forth to the printers in Paris became
increasingly onerous. This was partly why he
was attracted to linocuts, which could be
printed locally by Hidalgo Arnéra. Picasso's
first experiment with colour linocut, the
*Portrait of a Young Girl, after Cranach the
Younger* (cat.77), had highlighted the problem-
atic and time-consuming business of cutting
separate linoleum blocks and registering them
correctly to show a single unified image. In
1959 Picasso developed a completely new and
much simpler approach. Instead of using a
separate linoleum block for each colour, he cut
the block, printed a full edition of fifty sheets,
and then returned to the same block which he
re-cut and then reprinted in a different colour
over the same sheets. He would progressively
cut and reprint, depending on the number of
colours he wanted in each linocut. Between
1959 and 1962 Picasso made about one hun-
dred linocuts using this technique. All of them
were printed by Arnéra in Vallauris. This is one
of about fifteen linocuts, made in 1959, on the
theme of the bullfight. It incorporates three
colours – an overall background beige, and
brown and black. The lighter colours would
always be printed first. Picasso's fondness for
these colours relates to his love of ancient Attic
pottery, which strongly influenced the pottery
he was making at the Madoura pottery studios
at Vallauris at the time.

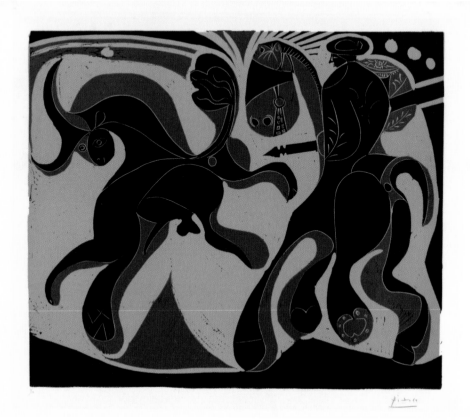

79

Lance III, 13 October 1959

[Pique III]
Colour linocut, 52.8 × 64cm image; 62 × 75cm sheet
Staatsgalerie Stuttgart, Graphische Sammlung
Inv. A 81/5929

This is one of two linocuts of the same scene that
Picasso made on 13 October 1959. They were printed
with a pale, blue-grey rectangular background and
the simple linocut was printed in black.

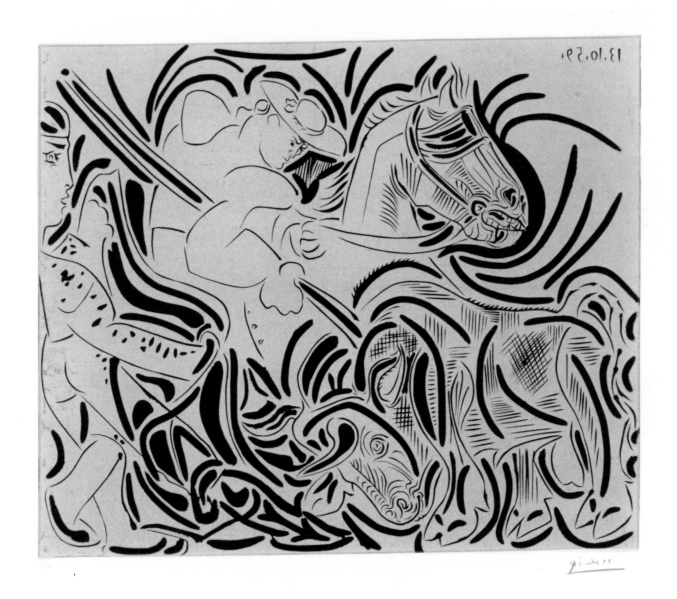

127

:chanal, 27 November 1959

[Bacchanale]
Colour linocut, 52.5 × 63.6cm image;
62.1 × 75cm sheet
Scottish National Gallery of Modern Art
GMA 825; purchased 1962

Picasso pioneered the linocut technique of using just one block of linoleum, which was re-cut and re-inked to make each colour. However in a number of his more complicated images, he cut the rectangular linoleum block into separate parts, and re-cut each part separately (this is a technique Edvard Munch had pioneered). Here the linoleum block was cut into two separate sections (sky and lake background; and foreground) and printed with five colours, plus an overall beige background colour.

81
**Jacqueline with a Hair Band. I,
13 February 1962**

[Jacqueline au bandeau. I]
Colour linocut, 35.1 × 27.1cm image;
62.9 × 44.4cm sheet
Staatsgalerie Stuttgart, Graphische Sammlung
Inv. A 63/2558

This four-colour linocut is from a series of
linocuts of Jacqueline's head made in 1962.

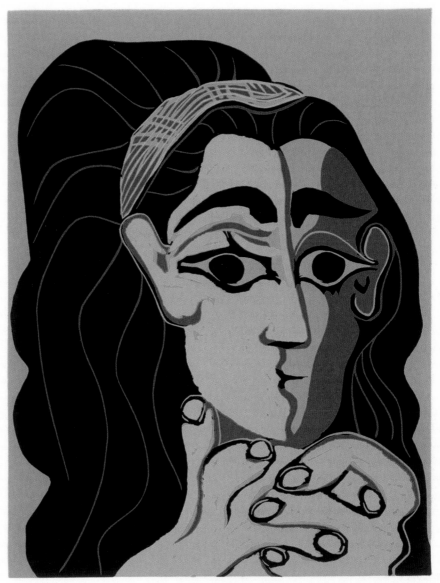

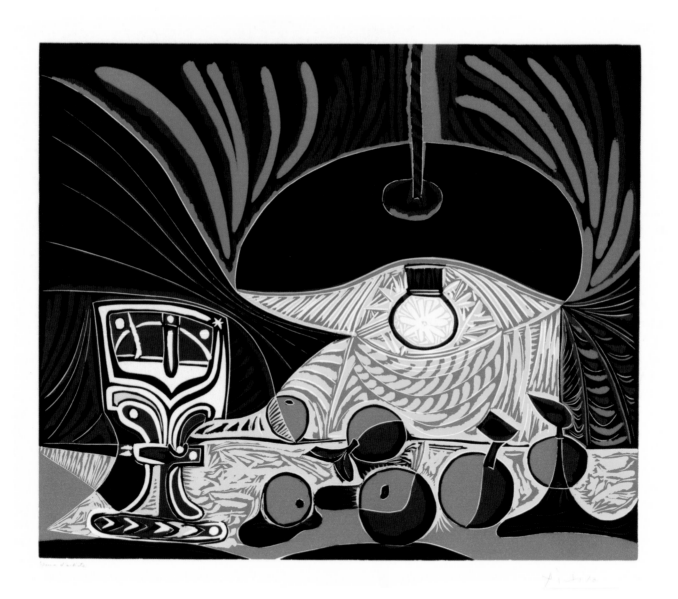

130

82

Still Life with a Glass under Lamplight, 19 March 1962

[Nature morte au verre sous la lampe]
Colour linocut, 35 × 26.9cm image;
62.9 × 44.4cm sheet
Staatsgalerie Stuttgart, Graphische Sammlung
Inv. A 64/3992

Still Life with a Glass under Lamplight is one of Picasso's greatest linocut prints. It was made from a single linoleum block, cut four times and printed in yellow, red, green and black. The colours would have been printed in that order, with the lighter colours followed by the darker ones. It is one of six very different linocuts made in 1962 showing a hanging lamp illuminating a still-life on a table. They were made at Notre-Dame-de-Vie, the villa in Mougins, north of Cannes, into which Picasso and his new wife Jacqueline had moved in 1961. The printer Hidalgo Arnéra would visit Picasso there, pick up the linoleums, print them at his press in nearby Vallauris, and then return with the proofs for the artist to inspect. This print was made in March 1962. It was given to the Staatsgalerie Stuttgart by Daniel-Henry Kahnweiler.

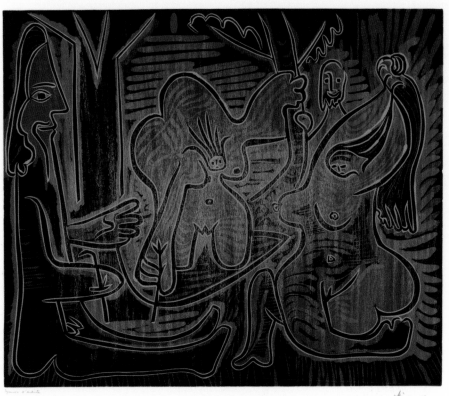

83

Luncheon on the Grass, after Manet. II, 23 April 1962

[Le Déjeuner sur l'herbe, d'après Manet. II]
Colour linocut, 52.8 × 63.7cm image;
62.2 × 75.2cm sheet
Staatsgalerie Stuttgart, Graphische Sammlung
Inv. A 64/3991

Picasso made numerous paintings, drawings and prints after Manet's celebrated painting of 1863, *Déjeuner sur l'herbe*. His first variant dates from 1940, but from 1959 to 1962 he made dozens of painted, printed and even sculptural versions, in what would be his last substantial reworking of a specific old master painting. This linocut was printed from a single block of linoleum, cut and printed four times, in black and three shades of brown. The subject of the male voyeur (a stand-in for the artist) keenly observing female nudes became increasingly important to Picasso in his later work.

84

Embrace. I, 15 October 1963

[Etreinte. I]
Washed linocut, 53 × 63.8cm image;
62 × 75cm sheet
Staatsgalerie Stuttgart, Graphische Sammlung
Inv. A 91/6571

In 1963 Picasso developed a new linocut
technique. This involved printing the linocut in
creamy-white ink onto white paper, and then
painting the same sheet of paper with black
Indian ink. The paper was then rinsed in a shower,
something Picasso enjoyed doing himself. The
black ink is absorbed into the unprinted areas, but
it is otherwise repelled by the greasy cream ink.
This technique produces an image which looks as
if it has been painted as much as printed. Roland
Penrose witnessed the process when he visited
Picasso in 1963: 'I found him with some large
white sheets of paper which had just been
returned by the printer. Impressions in white
printer's ink which were almost invisible had
been taken on them from the block of a large
lino-cut. This had not penetrated into the lines of
a drawing incised in the lino which could still be
seen faintly. Picasso, armed with a large pot of
Indian ink and a brush, asked me to accompany
him and Jacqueline to an upstairs bathroom. With
sweeping gestures he covered entirely each sheet
of paper with the ink, and then handed them one
by one to Jacqueline and myself to wash off under
the shower. The result was astonishing. The black
ink was almost entirely washed away from the
surfaces protected by the white printer's ink,
leaving only a grey uneven ground over the
whole print, but it remained and stood out boldly
where the Indian ink had entered into the lines
engraved by the linoleum' (Penrose 1981,
pp.451–2). The subject matter in this linocut
relates to a group of contemporaneous paintings
on the theme of the Rape of the Sabines.

85

**Painter and Model. IV,
5 December 1963**

[Peintre et modèle. IV]
Aquatint, etching and drypoint,
37.8 × 49.6cm plate; 51.4 × 66.6cm sheet
Staatsgalerie Stuttgart, Graphische
Sammlung
Inv. A 66/4447

In the 1960s Picasso withdrew increasingly from the
outside world, preferring the solitude of his villa at
Mougins. On his instructions his wife Jacqueline would
keep visitors waiting at the nearby hotel for days and
sometimes weeks before he would see them, if indeed he
saw them at all. During this period, his works came to
represent his own personal concerns, particularly the act
of painting and sexual fantasies. The *Painter and Model*
series is not exactly autobiographical: Picasso rarely used
a palette (he preferred newspaper), he hardly ever
worked from the live model and he never grew a beard.
The model does, however, seem to be based on Jacqueline.

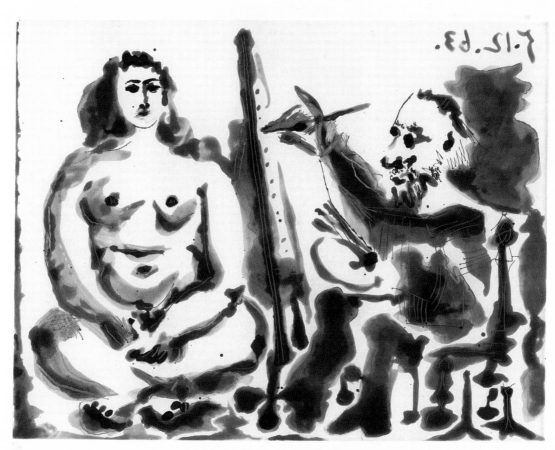

86
Reclining Nude, Child and Cock, 20 September 1967

[Nu couché, enfant et coq]
Pencil, 56 × 76cm
Staatsgalerie Stuttgart, Graphische Sammlung
Inv. c 69/1734

This drawing was made just a fortnight before *Man and Woman* (cat.87). It is one of many, mainly late drawings, in which a nude and a male figure are presented in a frieze-like fashion, with the figures occupying the right and left halves of the sheet. The male figure is usually an old, passive and physically small voyeur, while the woman is big, youthful and sexually provocative. Here, the young boy could be Cupid, sitting between the male figure of the cock and the writhing female nude. At the time they were made, the explicitly erotic nature of these late works led many to dismiss them as the work of an old artist who had lost his touch and his mind. However, in recent years they have attracted considerable interest.

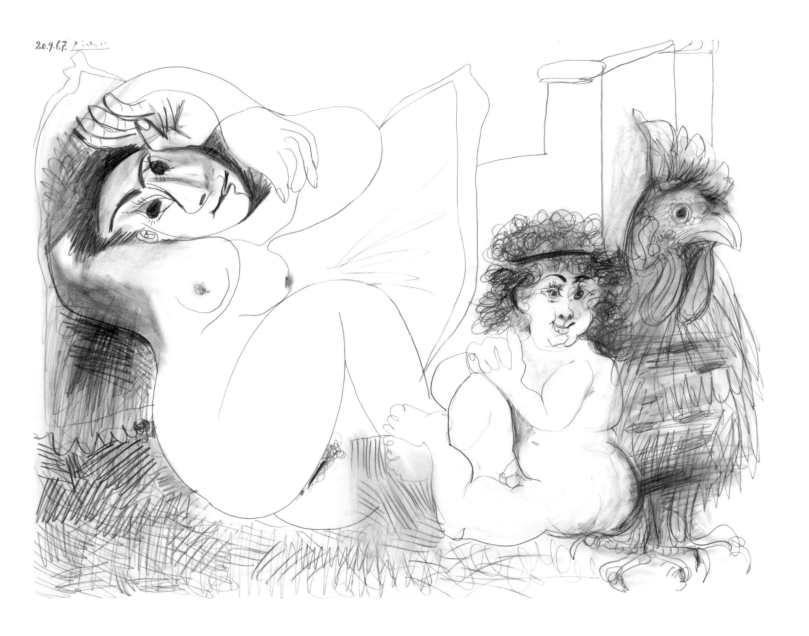

20.9.67. Picasso

135

87

Man and Woman, 2 October 1967

[Homme et femme]
Pastel, coloured pencil, and wash, 55.6 × 75.2cm
Scottish National Gallery of Modern Art
GMA 3892; purchased with assistance from the
National Heritage Lottery Fund and The Art
Fund 1995

A number of Picasso's drawings from the late
1960s involve characters who seem to emerge
from seventeenth-century art, particularly
Rembrandt. They are sometimes referred to as
'musketeers'. Here the comical male figure (a
kind of alter ego for Picasso) sits on a potty and
impotently points his phallic pipe in the direction
of the female nude. This drawing was dedicated
to Lee Miller on 22 January 1968. That week, she
and her husband Roland Penrose travelled to
Picasso's home in Mougins: there they spent
several days unpacking and checking the many
works which had been lent to the huge exhibition
of Picasso's sculpture which Roland had organ-
ised at the Tate Gallery in London. To thank the
couple for their help, Picasso dedicated this draw-
ing to Lee and another (cat.88) to Roland.

2.10.67.

22.1.68.

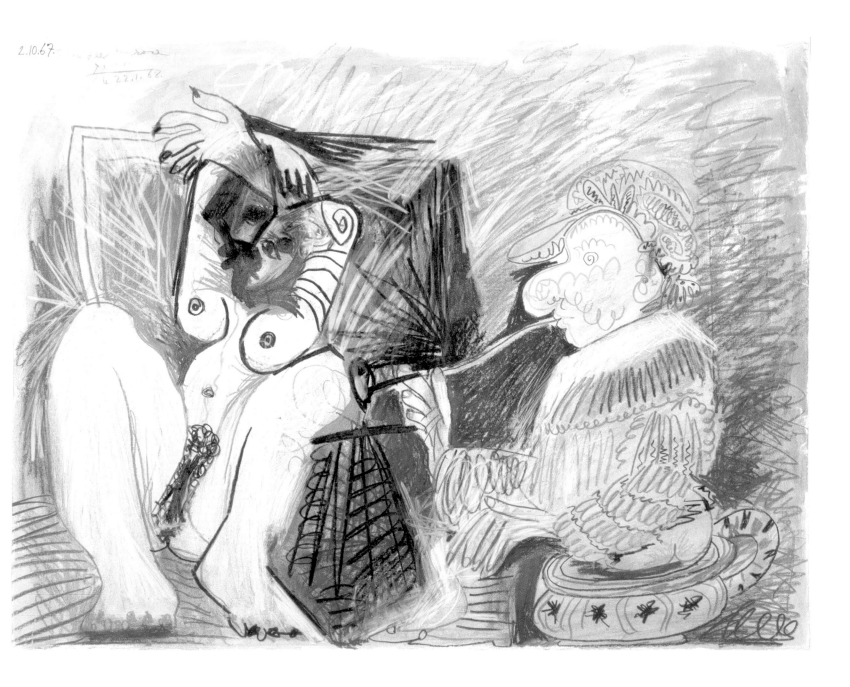

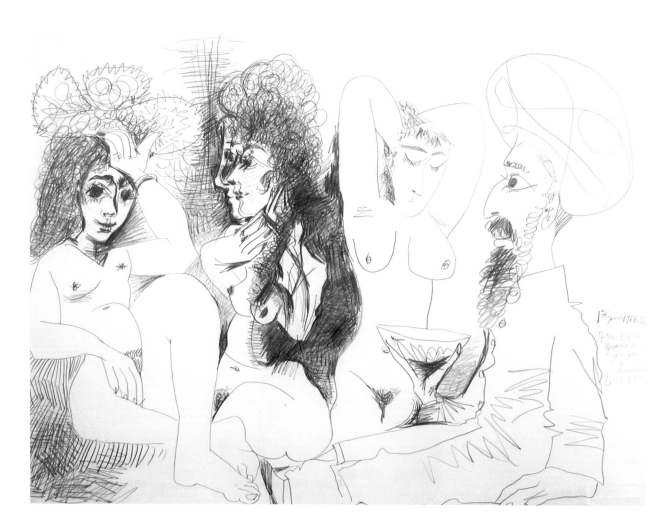

88
Three Nudes and a Turbaned Man holding a Cup, 22 January 1968

[Trois femmes nues et oriental à la coupe]
Pencil, 56 × 76cm
The Penrose Collection, England

The figure in the turban seems to be based on Piero Crommelynck, one of the brothers who printed Picasso's etchings during these late years (see Rubin 1989, pp.24–5). Whereas the incontinent old man in *Man and Woman* (cat.87) points his pipe impotently at the writhing nude, here the more virile man holds a cocktail glass which echoes the shape of the women's crotches. For the provenance of this work, see cat.87.

89

At the Circus: Horse-rider, Clown and Pierrot, 19 April 1968

[Au Cirque: écuyère, clown et pierrot]
Aquatint, 31.8 × 39.4cm plate;
47.2 × 56.5cm sheet
Staatsgalerie Stuttgart, Graphische Sammlung
Inv. A 69/4675

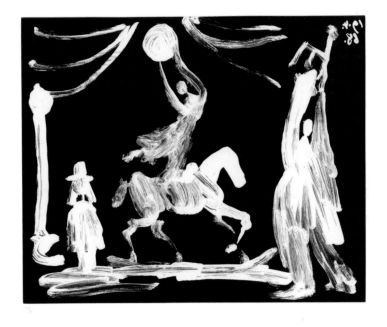

In February 1968 Picasso's secretary and friend of seventy years, Jaime Sabartés, died. A month later, on 16 March, Picasso began a vast etching project, making 347 etchings in less than seven months (the last etching is dated 5 October 1968). The prints deal with a variety of themes, but many of them were inspired by old Spanish literature, perhaps as a kind of homage to Sabartés, who had played a leading role in establishing the Picasso Museum in Barcelona. Other prints in the series centre on the circus, the bullfight and the theatre. Themes from earlier prints, including the *Vollard Suite*, also appear. They were made at Picasso's villa at Mougins and were printed by Aldo and Piero Crommelynck, brothers who had established an etching studio nearby. Aldo later recalled: 'The way it worked in *Suite 347*, was that I provided Picasso with a stock of plates in various sizes, prepared with various grounds. I would identify the ground on the wrapping paper. The small plates were designed to illustrate a book, Fernando de Rojas's *La Célestine* […] But the subject matter expanded onto the larger plates, which I couldn't use for the book. The theme influenced a large part of *Suite 347*: Célestine appears frequently' (Cohen 1995, p.16). Picasso himself commented on the suite as follows: 'Of course, one never knows what's going to come out, but as soon as the drawing gets underway, a story or an idea is born, and that's it … It's great fun, believe me. At least, I enjoy myself no end inventing these stories, and I spend hour after hour while I draw, observing my creatures and thinking about the mad things they're up to; basically, it's my way of writing fiction' (Otero 1974, p.170). The full set of prints was given the title *Suite 347*. They were printed in editions of fifty each, and published by the Galerie Louise Leiris in 1969. This print was made in a technique called 'manière noire' (black manner). It involves painting on a copper plate that has been given an aquatint resin surface, with a brush dipped in varnish.

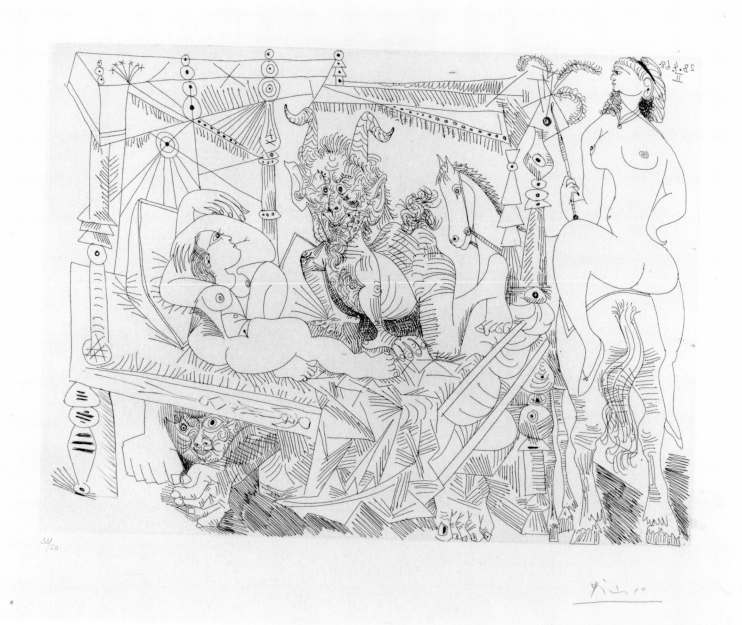

90

Fantasy in the Style of Fuseli's Nightmare, with a Voyeur under the Bed, 28 April 1968

[Fantaisie dans le genre du rêve de Füssli, avec voyeur sous le lit]
Etching, 28 × 38.9cm plate; 45 × 54.5cm sheet
Staatsgalerie Stuttgart, Graphische Sammlung
Inv.A 69/4886

This was part of the *Suite 347* series (see cat.89). Picasso almost never titled his prints. The title of this work was given by Brigitte Baer in her catalogue raisonné of Picasso's engraved work, but any resemblance to Fuseli's painting *The Nightmare* is probably coincidental. The brazen sexual content of Picasso's late work owes something to Degas's brothel monotypes, which Picasso collected.

91

Le Cocu magnifique, 1966 (published 1968)

[The Magnificent Cuckold]
Book with twelve etchings, some with aquatint and drypoint, each 22.2 × 32.2cm plate;
28 × 38cm sheet
Staatsgalerie Stuttgart, Graphische Sammlung
Inv. D 69/385
Illustrated: plate five

Le Cocu magnifique. Farce en trois actes was first performed in 1920. It was written by the Belgian playwright Fernand Crommelynck, father of Aldo and Piero Crommelynck, who collaborated with Picasso at their etching studio in Mougins from 1963. The twelve etchings selected for the publication (four for each of the three acts) were part of a group of more than sixty made by Picasso in November and December 1966. Their relationship to the text – a tragic farce about a man consumed by jealousy – is loose, but the eponymous cuckolded man seems to be the figure who wears the bull's horns. The book was published by the Atelier Crommelynck in 1968. Baer notes that Picasso made twenty-four prints of the same dimensions, and that the twelve not selected for *The Magnificent Cuckold* were subsequently used for another publication, *The Burial of the Count of Orgaz* (cat.92). (See Baer 1983, p.173.) Picasso was not the only artist to show an interest in Fernand Crommelynck's play: the Russian artist Lyubov Popova designed stage sets for a production in 1922.

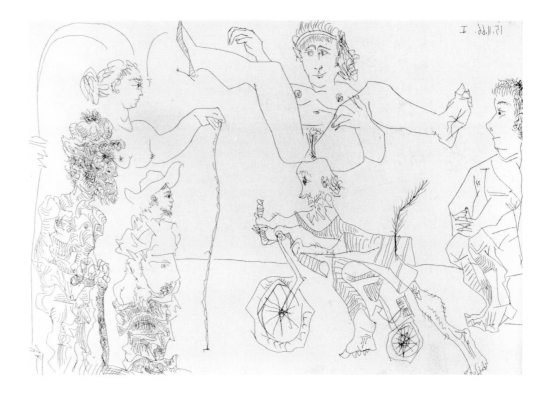

92

**El Entierro del Conde de Orgaz,
1966–7 (published 1969);
drawing 19 January 1971**

[The Burial of the Count of Orgaz]
Book with twelve etchings, one engraving and
one pen drawing on the title page,
36 × 46.2cm sheet size
Scottish National Gallery of Modern Art
A.35/2/RPL1/0015; purchased with the help
from the National Heritage Memorial Fund
and The Art Fund 1994
Illustrated: title page with original
pen drawing

So long as General Franco was in power, Picasso refused to visit Spain. Nevertheless, he felt nostalgic for his homeland and in the late 1950s he began to write in Spanish. From 1957–9 he composed a poem, *El Entierro del Conde de Orgaz*, inspired by the celebrated painting by El Greco. Ten years later it was published in Barcelona. Picasso provided fifteen prints dating from 1966 and 1967 (three of which were aquatints which only appeared in the de-luxe edition) and an engraving of 1939. The plate sizes are the same as those used for the etchings in the book *Le Cocu magnifique* (cat.91) and they were made at about the same time. Some of the images in the two

books are almost interchangeable, so it seems that they were not necessarily etched with a specific project in mind. The book was published in an edition of 263 copies and came with a separate volume which contains a facsimile edition of Picasso's text.

This copy of the book contains a magnificent title page drawing by Picasso. Roland Penrose purchased the book when he visited the enlarged Museu Picasso in Barcelona in January 1971. He travelled on to Picasso's home at Mougins the following week. As Elizabeth Cowling notes: 'Penrose … must have brought it with him to Mougins in the hope that Picasso would make some sort of embellishment. He was in luck because the drawing spreading across the opening is a wonderfully fluent and assured example of Picasso's late graphic style. A characteristic blend of beauty and grotesquerie, full of witty echoes of Spanish painting of the Golden Age, it contrives to suggest through the three characters depicted an entire narrative of cheerful pagan sensuality, lachrymose Catholic guilt and worldly cynicism – an archetypal scene from the eternal *comédie humaine*' (Cowling 2006, p.331). The drawing is dated 19 January 1971 and is dedicated to 'mon ami Roland Penrose'.

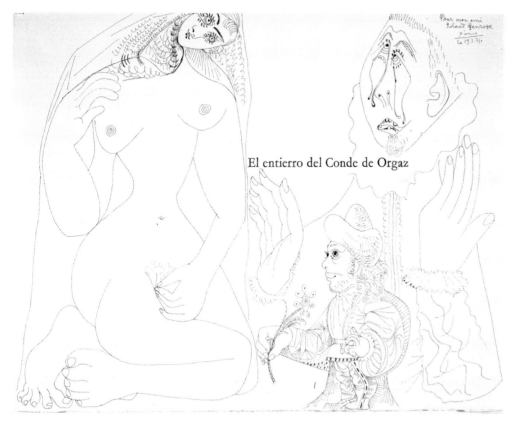

El entierro del Conde de Orgaz

Selected Bibliography

Baer 1983
Brigitte Baer, *Picasso the Printmaker: Graphics from the Marina Picasso Collection*, Dallas, 1983

Baer 1986–96
Brigitte Baer, *Picasso Peintre-graveur*, Bern, vols.I-VII, 1986–96

Baer 1988
Brigitte Baer, 'Seven Years of Printmaking: The Theatre and Its Limits', in *Late Picasso: Paintings, Sculpture, Drawings, Prints, 1953–1972*, London, 1988

Baer 1992
Brigitte Baer, *Picasso Graveur: Les 156 Gravures, Mougins 1968–1972*, Saint-Etienne, 1992

Baer 1997
Brigitte Baer, *Picasso the Engraver: Selections from the Musée Picasso, Paris*, New York and London, 1997

Baer 1998
Brigitte Baer, 'Where do they come from – Those Superb Paintings and Horrid Women of "Picasso's War"?', in *Picasso and the War Years 1937–1945*, New York and London, 1998

Barr 1946
Alfred Barr, *Picasso: Fifty Years of His Art*, New York, 1946

Benadretti–Pellard 2001
Sandra Benadretti-Pellard, *Picasso à Vallauris: Linogravures*, Musée Magnelli, Musée de la Céramique, Vallauris, 2001

Bloch 1968–79
Georges Bloch, *Pablo Picasso. Catalogue de l'oeuvre gravé et lithographié*, 4 vols., Bern, 1968–79

Bollinger 1956
Hans Bollinger, *Picasso's Vollard Suite*, London, 1956

Brassaï 1964
Brassaï, *Conversations avec Picasso*, Paris, 1964

Cohen 1995
Jamie Cohen, Karen Kleinfelder and Aldo Crommelynck, *Picasso: Inside the Image*, New York and London, 1995

Contesou 1979
Bernadette Contesou and Danielle Molinari, *L'Atelier Lacourière-Frélaut*, Paris, 1979

Cowling and Golding 1994
Elizabeth Cowling and John Golding, *Picasso: Sculptor/Painter*, London, 1994

Cowling 2002
Elizabeth Cowling, *Picasso: Style and Meaning*, London and New York, 2002

Cowling 2006
Elizabeth Cowling, *Visiting Picasso: The Notebooks and Letters of Roland Penrose*, London, 2006

Daix 1979
Pierre Daix, and Joan Rosselet, *Picasso: The Cubist Years 1907–1916*, London, 1979

Duncan 1974
David Douglas Duncan, *Goodbye Picasso*, New York, 1974

FitzGerald 1995
Michael C. FitzGerald, *Making Modernism: Picasso and the Creation of the Market for Twentieth-Century Art*, New York, 1995

Florman 2000
Lisa Florman, *Myth and Metamorphosis: Picasso's Classical Prints of the 1930s*, Cambridge, Mass., 2000

Fryberger 1999
Betsy G. Fryberger *et al.*, *Picasso: Graphic Magician. Prints from the Norton Simon Museum*, Stanford, 1999

Gauss 2000 (1)
Ulrike Gauss (ed.), *Pablo Picasso Lithographs*, Ostfildern-Ruit, 2000

Gauss 2000 (2)
Ulrike Gauss (ed.), *Pablo Picasso. Werke auf Papier in der Graphischen Sammlung der Staatsgalerie Stuttgart*, Stuttgart, 2000

Geiser 1955
Bernard Geiser, *Picasso: Fifty-five Years of his Graphic Work*, London, 1955

Gilot 1964
Françoise Gilot and Carlton Lake, *Life with Picasso*, New York, 1964

Giraudy 1992
Danièle Giraudy (intro.), *Picasso Linograveur*, Montpellier, 1992

Goeppert 1983
Sébastien Goeppert, Herma Goeppert-Franck and Patrick Cramer, *Pablo Picasso. The Illustrated Books: Catalogue Raisonné*, Geneva, 1983

Goeppert 1987
Sébastien Goeppert, Herma Goeppert-Franck and Patrick Cramer, *Minotauromachie by Pablo Picasso*, Geneva, 1987

Harris 2002
The Richard Harris Collection, *Picasso: Master Printmaker*, New York, 2002

Karmel 2003
Pepe Karmel, *Picasso and the Invention of Cubism*, New Haven and London, 2003

Léal 1996
Brigitte Léal, *Musée Picasso. Carnets. Catalogue des dessins vols.1 & 2*, Paris, 1996

Lieberman 1985
William S. Lieberman (intro.), *Picasso Linoleum Cuts. The Mr and Mrs Charles Kramer Collection*, New York, 1985

McCully 1997
Marilyn McCully (ed.), *Picasso: The Early Years, 1892–1906*, Washington, 1997

Mourlot 1970
Fernand Mourlot, *Picasso Lithographs*, translation of 4 vols. French text, with additional information, by Jean Didry, Boston, 1970

Muller 2004
Markus Muller, *Pablo Picasso & Marie Thérèse Walter: Between Classicism and Surrealism*, Munster, 2004

Nash 1998
Steven A. Nash (ed.), *Picasso and the War Years 1937–1945*, New York and London, 1998

Olivier 1974
Fernande Olivier, *Picasso and His Friends*, New York, 1974

Otero 1974
Robert Otero, *Forever Picasso*, New York, 1974

Penrose and Golding 1973
Roland Penrose and John Golding (eds.), *Picasso in Retrospect*, London, 1973

Penrose 1981
Roland Penrose, *Picasso: His Life and Work*, London, 1981

Richardson 1991
John Richardson with Marilyn McCully, *A Life of Picasso. vol.I: 1881–1906*, New York, 1991

Richardson 1996
John Richardson with Marilyn McCully, *A Life of Picasso. vol.II: 1907–1917: The Painter of Modern Life*, London, 1996

Richet 1988
Michelle Richet, *The Musée Picasso, Paris. Catalogue of the Collections vol.II: Drawings, Watercolours, Gouaches, Pastels*, London, 1988

Rubin 1980
William Rubin (ed.), *Pablo Picasso: A Retrospective*, New York, 1980

Rubin 1989
William Rubin, *Picasso and Braque: Pioneering Cubism*, New York, 1989

Rubin 1996
William Rubin (ed.), *Picasso and Portraiture: Representation and Transformation*, New York, 1996

Sabartés 1948
Jaime Sabartés, *Picasso: An Intimate Portrait*, New York, 1948

Schiff 1983
Gert Schiff, *Picasso: The Last Years, 1963–1973*, New York, 1983

Schiff 1987
Gert Schiff, 'Picasso's Old Age: 1963–1973', in *Art Journal*, vol.46, no.2, summer 1987, pp.122–6

Tinterow 2006
Gary Tinterow, 'Vollard and Picasso', in Rebecca A. Rabinow (ed.), *Cézanne to Picasso: Ambroise Vollard, Patron of the Avant-Garde*, New York and Yale, 2006

Wofsy, Alan 1995– present
Alan Wofsy, *The Picasso Project: Picasso's Paintings, Watercolors, Drawings and Sculpture. A Comprehensive Illustrated Catalogue 1885–1973*, San Francisco, 16 vols. to date, 1995–present

Zervos 1932–78
Christian Zervos, *Pablo Picasso*, 33 vols., Paris, 1932–78

Notes to the essay

1 Penrose 1981, p.13.

2 Richardson 1991, pp.62–3.

3 Sabartés 1948, p.13.

4 Ibid., p.14.

5 Baer 1997, p.55.

6 Baer 1997, p.72.

7 Baer 1983, p.73.

8 Lieberman 1985, p.10.

9 Sabartés 1948, p.162.

10 Gilot 1964, p.88.

11 Ibid., p.89.

12 Mourlot 1970, n.p.

13 Ibid.

14 *Cahiers d'Art* 1935, vol.10, no.10, pp.173–8, translated in Barr 1946, p.272.

15 Duncan 1974, p.39.

16 Interview with Hidalgo Arnéra in Benadretti-Pellard 2001, p.17.

17 Harris 2002, p.31.

18 Interview with Aldo Crommelynck in Cohen 1995, pp.13–14.

19 Interview with Aldo Crommelynck in Baer 1992, pp.41–3.

20 Cohen 1995, p.16.

21 Cowling 2006, p.332–3.

Works in the collection of the National Galleries of Scotland were photographed by Antonia Reeve